American Tradition in Painting

American

Tradition

in Painting

JOHN W. McCOUBREY

GEORGE BRAZILLER NEW YORK

For information address the publisher:
George Braziller, Inc.
One Park Avenue
New York, New York 10016

Standard Book Number: 0-8076-0215-9 (Hardbound Edition)
 0-8076-0572-7 (Paperbound Edition)
Library of Congress Catalog Card Number: 63-11371

Printed in the United States of America

Second Printing, 1970

Contents

List of Plates

Introduction

*To reconstruct in Europe the artistic substance
of America may be hardly possible: its connection
with our own is often slight. Its birth and rebirth
are wholly American. No other art is likely to be born
again in just this way, in the American shape. The
paint in the pot is different. Why did the American
idea not occur to anyone before? It did: it was in the air
in Europe for a quarter of a century. It required to be
filled with the unique American substance, the
material poetry of the country, to gain its present force.*

*Lawrence Gowing
"Paint in America"
New Statesman, May 24, 1958.*

Through the dazzling canvases of our abstract expressionists, shown and imitated from Tokyo to Paris, America has at last made a decisive contribution to painting. Our critics have been quick to point out the debt owed by the post-war Americans to Europe and, in the light of that debt, to claim a deserved international significance for the Americans. Certainly this new American painting would not have been possible without the cubist revolution or Picasso, without German expressionism or Kandinsky, without the "accidents" of the Dada painters or the automatism of the surrealists. Yet this art was born in the United States, in the American shape. It is imbued with "the material poetry of the country" and is part of a native visual tradition that it both continues and illuminates. This essay is an attempt to describe the many elements of continuity in the native American vision.

The special look of American painting is the product of many forces working diversely upon it and producing often unsuspected results. It is frequently, and most damagingly, said that our art is only a pale, provincial imitation of European models. It is now no longer that, but the best of our painting has never been *only that*. A leavening has always been at work transforming what little has been learned into something uniquely American. Part of this leavening is what the artist sees in America: the brilliant, all-discovering light; the raw, unsettled landscape; the unfinished and transient look of what has been built upon it; the jarring tangle of our signboards; and, everywhere, the debris of our headlong consumption of goods.

The realism of our painting, its most consistent and obvious characteristic, has been described as a reflection of the allegedly hard-headed and practical people who are said to live here. But there is a deeper and more important accord between the realism of our pictures and American experience. Nature as it is observed never makes a picture, and the accuracy with which our artists have observed American scenery has enabled them to ignore or consciously to reject those traditional skills which have been at the heart of the European tradition. Increasingly since the Renaissance these skills have served the European painter to convey not just a convincing image, but a heightened awareness of objects or figures in an illusion of ordered space. Our art is possessed by the spaciousness and emptiness of the land itself.

No American painter can ignore it; to make its presence felt in his work, he has consciously avoided, or never needed, those skills which traditionally bottle up, control, and make habitable pictorial space. Our landscapes are right not only because of their topographical correctness, but also because our painters have not needed a sophisticated style to convey the land's alien emptiness. Nature, particularly in America, cannot be shaped and hollowed, as European painters, establishing an ideal order, have molded it. Spaciousness is at home in America not only in our landscapes but in all of our painting. Thus, figures in American pictures—like their viewers—are not given an easy mastery of the space they occupy. Rather, they stand in a tentative relation to it, without any illusion of command over it.

Furthermore, in European painting since the seventeenth century, a large measure of appeal in any picture has lain in touches of the brush which caused the painting to become an extension of the artist's personality; or in a manipulation of paint for its own sake, which converted the painting into an object of material splendor in its own right. The painted surface thus contends for the viewer's attention with illusionistic aspects of the representation. For the painstaking American realist especially intent upon reproducing what he sees, there is no place for sensuous appeal. In rejecting the traditional intercessions of the European artists, he produces pictures which are psychologically remote from the viewer with a technique admirably attuned to the remoteness of the landscape he has so often depicted. American puritanism has been doubly justified in demanding this technique of realism: firstly, because it does not appear to lie; secondly and more profoundly, because it ignores the sensuous, material elegance of the great tradition.

Nevertheless, there has always been a profound rightness, even in the most untutored efforts of our painters. The tight, precise style of our eighteenth-century portraitists may have been all they were capable of; but it was probably all that was permitted them. At least it would be difficult for us to imagine their sitters painted in any other way. Through all American painting, artists with an uncertain grip on their craft have repeatedly given us true images of a people who have an uncertain grip on their environment.

An analysis of the European parentage of our contemporary painting cannot adequately explain how abstract expressionism came into being. The differences between the two continental traditions are more important than

their similarities because they are a constant, a consistent historical factor. A Copley differs from a Gainsborough as an Eakins differs from a Courbet. It is not only a question of talent but of intent. In the realm of contemporary abstraction, where inequalities of talent and training are minimized, the sea-change continues to be worked.

A detailed comparison of a painting by Pierre Soulages (plate 1), and one called *Crosstown* (plate 2) by the late American painter, Franz Kline, will clarify what has been said and reveal how the present both continues and illuminates the past. These are superficially similar works, limited to a few bold strokes of the brush and restricted in color to blacks and near blacks.

The European painter is careful to structure his painting. Each stroke constitutes a single area which is precisely limited and kept within the edges of the canvas; with others like it, it builds a restful, self-possessed unity within the pictorial space. Although the marks of the brush are very much in evidence, they mark a stately progress across the surface and proclaim the artist's pride of craft and his mastery of material.

In contrast, the American painting appears raw and violent, without any pretention to small perfections. Its scarred, hostile surface seems crudely and impulsively painted. The brush strokes reach to the very edge of the canvas and seem hardly contained by the frame. There is no point of rest in the composition but, rather, an apparently willful randomness. It cannot be read, as can Soulages' painting, as a material object—or figure—against a ground.

From the confrontation of these two abstractions emerge larger distinctions. Behind the French work lies a long tradition of painting which Americans have known only from a distance: a tradition of order manifested in the precise, stable location of shapes, the structure of horizontals and verticals with their implication of weight and support. To the impression of order and material presence conveyed by this structure is added the painter's indulgence in the richness of his medium. Paint is nurtured for its own sake, to be enjoyed in itself. Kline's picture cannot be grasped in the same way. Paint is consumed but not cherished, pushed in apparent haste—in pursuit not of a fictive order but of a disordered, momentary impression of forces perilously joined and constantly threatened by change or disintegration.

Compared to the traditional properties of the French painting, Kline's is more abstract.

This abstraction can only be grasped in terms of traditional concerns for order, stability, and material luxury. In relation to real objects or events, the American painting is more realistic, for Kline refers here to a real world of accident and chance, beyond his power to control. This reality is projected not only by the apparently haphazard relationship of forms but by the paint surface which, like reality itself, remains magnificently indifferent to the observer. Kline's picture is also pervaded by an American sense of space. His violent strokes of black, as they reach to the very edges of the canvas—and seemingly beyond—imply the continuation of vast distances, the presence of an enormous void, of which the area of the painting is but a fragment.

If these disoriented and fragmentary aspects of the American vision seem suspiciously like those of modern painting both here and abroad, it should be remembered that the conditions of modern life were present from the beginning in the political facts and awesome presence of the real and unknown American continent. American paintings can be understood in the light of their European relatives, but only so far as such a comparison reveals their inherent expressiveness. Ultimately, this expressiveness must be sought in the paintings themselves. Those reproduced in support of this essay are precisely the pictures Americans have come to know and love, perhaps because they contain just those elusive American qualities which we hope to reveal.

1. The Colonial Portrait

The Beauty of the world consists wholly of sweet mutual consents, either within itself or with the supreme being. As to the corporeal world, though there are many other sorts of consents, yet the sweetest and most charming beauty of it is its resemblance of spiritual beauties. The reason is that spiritual beauties are infinitely the greatest, and bodies being but the shadows of beings, they must be so much the more charming as they shadow forth spiritual beauties. This beauty is peculiar to natural things, it surpasses the art of man.

Jonathan Edwards
"The Beauty of the World"

Colonial painting in America embodied much that remains with us. *Mrs.
Freake and Baby Mary* (plate 3) was painted by a man who remem-
bered the stiff elegance of Tudor portraiture already two generations out of
style. Pictorial space and atmosphere were of no concern to him, nor was
the bodily weight of the figure. Instead, his eye was busy exclusively with
the surface on which he inscribed the edges of objects and described their
texture, treating the linen as though it were spread on the ground to dry.
The white cloth, peaking upward in the lady's cap, or pointing downward
in her apron or the baby's, steals the eye from the stable rectangle of the
frame and, with its brightness and quick fall, masks any sense of corporeal
repose the seated figure might convey. She is an early flower of the wilder-
ness pressed under glass, existing in an inaccessible, two-dimensional en-
vironment where she may not act and we may not enter. This weightless
congeries of angles, points, and flat unstable shapes is held together by the
innate taste of a journeyman who—with a vague memory of how pictures
were once painted, and the knowledge that he has made a finished, inde-
pendent thing—secured himself from the uncertainties of the visible world.
The immaterial world of Mrs. Freake is an essential form of the world which
American artists have continued to paint; not just the lineal descendants of
the Freake painter—Hicks, Pickett, Kane, Grandma Moses, and the rest
who make neither our history nor our national style—but the others in
greater number who have created an immaterial world out of their puritan
hesitancy to taste the real flesh of painting.

When Mrs. Freake of Boston had her portrait painted in 1674, the Puritan
oligarchy was already giving way before the forces of commerce and new
immigration. The march of swift change, which quickened with independ-
ence and has always denied America the look of permanence, had begun.
With it, eventually, came the professional artists trained abroad—Smibert,
Hesselius, Bridges, Blackburn, Wollaston—to make more fashionable like-
nesses of the ample merchants and softening divines. These displaced men
of mediocre talent painted pictures that tell us of their sitters' social preten-
sion; they even give, with chancy perspective and cursory effects of light on
flesh or folded cloth, a summary impression of the real world. In Smibert's
Bishop Berkeley and Entourage (plate 4), the blend of muted, old-masterish
colors, the studiously posed figures placed one behind the other in depth,

and the ghost of a baroque rise and fall in the composition, passed for proper painting. Perhaps a half-forgotten *Adoration of the Magi* lent its propriety and inspired him to put the Bishop in Joseph's place, beside his prim Madonna, and to make a self-portrait of the figure at the far left, which might have been the third Magus. But the gifts Smibert brought from the East were meager and perhaps unnecessary. A dozen years later, after Robert Feke had seen the Berkeley group in Smibert's painting room and begun his own *The Family of Isaac Royall* (plate 5), he showed little interest in the "heav'nly pencil" which had beguiled Boston.

Royall himself, standing straight against the picture's edge, presides over his ladies fixed one next to the other in an isolation enforced by bright colors abruptly shifting from orange to blue to red. Each figure is brought so close to the picture surface that the table before them is reduced to a thin, vertical plane. Against this rhythm of verticals, a line of forearms and below it a thin band of ornament, from Royall's coat across the turkey carpet, bind the group lightly. Yet these horizontals in no way interfere with the serene independence of the figures. Not one of them bends in feigned attention to his neighbor; there is no easy nonchalance as in the Smibert, no suggestion of an interrupted conversation, and only a suddenly pointed finger threatens their immobility. If there is a hint of weight in the figures and of real space in the dim background, the orderly rhythm of the figures across the surface, and the discontinuity of their pose and color deny the easy spatial adjustments of the baroque, to which Smibert vainly aspired, wherein the viewer is invited to consort with figures at a real moment in a convincing space.

The establishment of such a relationship was, it may be said, beyond Feke's limited ability; the flat surface pattern is a typical device of the untrained. A workmanlike desire to do little and do it well may account for the apparent restraint and tidiness of the Royall group. In the gentleman's scarlet jacket, the curved line, beautiful in itself, bending with the stiff grace of New England Queen Anne furniture, is an elegance perhaps only possible to a man more at home with real things well made than with imitations of them. But against this delicacy is the impact of each bright figure, the crisp assertive edges and severe geometry which suggest a desire to fix this family outside of time in a picture in which the fat of the baroque has been burned away and each of its subjects is left to stand inflexibly asserting the un-

adorned fact of his own existence.

Feke's spare style—like that of all our native colonial artists who, recognizing their own limitations, transformed the baroque into a linear and chaste colonial style—is readily distinguishable from that of others who painted, like Smibert, in hopeful emulation of artists trained abroad. The anonymous painter of *Adam Winne* (plate 6), for example, concentrated on a delicate surface play of straight lines and responding curves where edges touch in delicate tangency, respecting the integrity of each contour. The vertical window frame, touched lightly on one side by the firm, almost Florentine clouds, and brushed on the other side by the curving white sleeve, is left intact to act—with the white neckpiece—as a counterpoint to the smooth curves of the coat, the piping on the hat, and edges of white linen. These graceful rhythms give unity to the whole picture, binding together the separate objects and discontinuous space. The painter of *Edward Jacquelin* (plate 7), on the other hand, dressed up his sitter like one of Kneller's Dukes and fumbled for painterly effects borrowed, like the outfit, from an imported mezzotint. In the jagged lights and darks of the blue robe, only a trace of linear sensibility remains, and that all but obscured in the artist's effort to describe light and shade, mass and volume, in a space he could not construct. The robe, windblown where there is no wind, disrupts the linear context of the precise little figure behind it like a chord suddenly introduced and somewhat off key in a composition of pure, melodic line.

The man who painted Adam Winne, and the anonymous painters of the De Peyster and Van Cortlandt children, retain in their disciplined line and surface a coherent method of picture making—a method already apparent fifty years earlier in the portrait of Mrs. Freake and continued by Feke and Copley down to the time of the Revolution. These painters, the native, untrained artists of our prehistory, did not remain in constant but distant emulation of their capital. Their history was unique in that, without apparently learning whatever little could be had from their predecessors, they yet showed a steady improvement until Copley, in 1766, was able to attract favorable comment when he exhibited his *Boy with a Squirrel* at the Society of Artists' exhibition in London. This modest progress toward a more relaxed pattern, more convincing volume and lighting, cannot be attributed to any continuing studio tradition or any sudden discovery of new sources of inspi-

ration. It was discontinuous, like the history of our later painting, and depended upon the emergence of individuals of talent without masters and without pupils: individuals who, despite their growing competence, shared a pictorial sensibility more profound than the changes they worked upon it.

Thus, in contrast to *Mrs. Freake's* sharp angularity, the contours in *Adam Winne* become more fluid and graceful, even suggesting a hint of atmosphere in their openness. Feke's *Isaac Winslow* (plate 8) seems to convey at last an impression of light-filled atmosphere, and the linear patterns make more commanding sweeps through space than those of the earlier pictures. Yet there remains in both paintings a reliance on line. *Adam Winne* is almost as two-dimensional as *Mrs. Freake,* and Isaac Winslow does not really stand in the landscape he seems to command, but in front of it. His authority derives not from his physique or bulk but abstractly from the upthrust spear of white satin and the long curve of his jacket. These lift the eye dramatically over a long path to his face, while revealing nothing of the figure underneath. The atmosphere is created by uniformly clear local color and the light does not model but rather discovers the sharpness of the contours.

In the work of John Singleton Copley the peculiar development of colonial painting finds a culmination within the strict limits of the style. A glance at his *Mr. and Mrs. Thomas Mifflin* (plate 9) might suggest that, under his penetrating eye and agonizingly slow brush, a painting of the human figure convincingly modeled and lighted, at ease and capable of action in familiar surroundings, had at last been achieved. Yet Copley knew that such a picture could never be accomplished in the artistic poverty of New England. His American portraits are unique, but their special quality cannot be attributed entirely to his provincial clients or to his lack of training. They can be understood only in the light of the American intention which they both fulfill and reveal. If we look more closely at *Mr. and Mrs. Thomas Mifflin,* much of what we saw in Feke's Royall group remains. The two figures, though apparently casual in their pose, are of equal height, seated in a simple one-to-one relationship. An awkward heap of hands and a book which the husband heedlessly points at his wife's throat, separate them. They have no place to sit; the husband seems to emerge suddenly from nothing, behind the table. They are drawn together in this strange union by a tall space, of the sort usually calculated to impress people: a space they neither use nor

need. They bear no more relation to it than Mrs. Mifflin's small loom
bears to the column in the background. Yet, as they sit low in this space,
drawn toward its center, they gain a deeper relationship which transcends
their graceless confrontation.

In other pictures Copley, like his predecessors, obscures the human figure
by designs cut across the lines of human anatomy, and denies human weight
by giving only smooth bent surfaces. The portrait of *Isaac Smith* (plate 10)
cannot be read in the round; instead, the whole composition moves across
the surface, with the lower left edge of the jacket splayed forward and the
knees tucked back into the plane to which the whites, because of their equal
intensity, also conform. Isaac Smith is neither in control of his environment
nor outside of it; he creates one, not by his own energy but by the darting
stabs of white in his cuffs and quill, hose and powdered hair, and from the
net of lines which cross and curve, in patterns as restless and unresolved
as those on the back of his Chippendale chair. These quick lines and patterns
suggest a merchant of squirrel-like activity, but the bones and flesh of the
figure itself, weightless among the scattered whites and digressive lines,
negligible behind the counted buttons, and lost in the vibration of the plum
suit against the unthinkable blue drapery, do nothing.

Unlike his predecessors, Copley could create, in portraits like those of
Paul Revere (plate 11) or *Mrs. Ezekiel Goldthwait* (plate 12), a convincing
illusion of three-dimensional volume. He achieved it with startling success
in Paul Revere's teapot, in the ripe fruit which Mrs. Goldthwait reaches for,
and in the gleaming table tops which, in both pictures, measure the sub-
ject's position in pictorial space. But these round inanimate objects do not
serve the sitters formally or psychologically. The planes of the tables do not
echo or enhance their volume but slide back, cutting into the figures with
alien shapes. Beyond the space so explicitly measured by their polished sur-
faces—precisely at their distant edges—the figures are flattened out, and
that of Mrs. Goldthwait is pinned against an opposing plane formed by her
blue chair. These are spaces created not as stages to be peopled but by the
presence of solid inanimate objects. Here, although Copley abandons the
abstractive line and pattern of the Smith portrait for a more objective vision
of round things, and applies the detailed, polished surfaces of Feke to con-
vincingly present objects, he still approaches the corporeal reality of his sit-

ters by indirection. Overwhelmed by bright, new objects they seem neither to own nor to have used—objects less immediate to them than to the viewer —these persons gain real presence only through the implication of inanimate things.

Copley's art reveals, despite its "advances," essentially the approach of his predecessors. His paintings never contain a touch of bravura; he never used the brush for its own sake but only in the service of things as they were. Thus, the observer is forced to take in each object separately, in a communion which is never deeply empathetic but transformed into something akin to the artist's own immaterial process of vision. Copley admitted to "a kind of luxury in seeing," but there was no luxury in the labor of painting. When he did indulge the appetite of his senses for sumptuous color and gleaming surfaces, these indulgences get us no closer to the sitter; they contribute to a material, rather than to a human, reality. His paintings, even though they are portraits, reveal the same Calvinistic prohibition which, in the seventeenth century, drove so many Protestant painters from figure painting to still life. They embody a reversal of the humanistic doctrine of the academies and are to be read upward from the trivial objects of daily existence to the human figure whose presence they certify.

Copley's long career in London, from 1774, was spent in an attempt to acquire the facility of his English competitors, but his lack of early training and his slow working methods told against him. His famous *Watson and the Shark* (plate 13), painted in 1778 shortly after his departure from Boston, reveals an effort, typical of American painters abroad, to assimilate, at one fell swoop, the complexities of European figure composition. In the central, pyramidal group he succeeds well enough, perhaps through the study of prints or of paintings he saw in London. The paired, reaching figures, for example, perhaps go back to similar figures in a descent from the cross. In the central group, too, through violent diagonals composed of contrasting thrusts and pulls, he sustains the excitement of the dreadful encounter in the water. The shark and his victim, however, are without precedent; the shark thrusts suddenly and almost comically at his victim who is miraculously buoyed by the waters of Havana Harbor. There is also an effective naïveté in the composition as a whole which negates the surprising correctness of the figures in the boat and, while consistent with the naïve handling of Watson

and his attacker, endows the picture with a properly shocking immediacy inaccessible to traditional methods of composition. The shark's head and the nude body of Watson are brought forward in the picture until the observer too feels menaced. The rescuers' boat, although empty of figures at the stern, is carried to the left edge of the canvas, its lateral extension emphasized by the oar which disappears beyond the picture's edge. The uppermost figures are thrust toward the top of the painting, and the boathook, held by the figure on the right, disappears at the top as the oar does on the left. The effect is a sudden convergence of violent movement, like that in Kline's picture, precariously and momentarily balanced.

The effectiveness of this untutored arrangement, as American as the scattered patterns of the Isaac Smith portrait, may be measured against a smaller version of the same picture in Detroit (plate 14). Here, undoubtedly at the suggestion of his new mentors, Copley produced a more conventionally correct version in which the action is drawn away from the top and bottom edges, and the format is changed to a vertical rectangle with an ample area of sky above the figures. The action is set well back into the picture space and, because it is so nicely framed, takes on a more monumental quality. But the intuitive rightness of the earlier version, with its wild and fortuitous projection of sudden shock, is gone. Copley's transformation—suggested by this comparison—from an unpredictable yet original provincial into a competent but third-rate *émigré*, has been the fate of many American painters who have too zealously pursued an alien facility.

For a time after Copley's departure in 1774, his pictures inspired a few native painters: Ralph Earl, the young Trumbull, and, possibly, Charles Willson Peale. Of these, Earl was closest to Copley in spirit. His early *Roger Sherman*, clad in brown homespun and black stockings, seated uneasily in a bare, somber room, is a document of the unyielding Puritan temperament —even more so than Copley's Bostonians. In Philadelphia, Peale's early *Family Group*, in contrast to the New England paintings, is a lighthearted conversation piece; but the hard, distractive still lifes remain, adding a more convincing reality to the harshly modeled figures and their humanistic setting of painters' tools and portrait busts. For Peale this gift for brute imitation was a plaything out of which he later developed, unlike Copley, a genuinely popular art discernible in his *trompe-l'oeil* portrait of his sons, and later

continued in their own works. Earl and Peale walked on opposite sides of Copley's narrow way, the former toward a bare, introverted style, the latter toward a more extroverted, human one. Yet both of them remained within the colonial tradition. So too did Trumbull in the early American portraits of his family, but when his efforts were described in London as "bent tin," he joined West, Stuart, and Copley in a search for an elusive English competence that he never quite found.

The New England painters produced the first manifestation of an American style. In the colonies to the south, art was less suspect and could not produce a Feke or a Copley who, though the iconoclasm of the Puritan theocracy had waned, still viewed the world with covert affection. The New England style was a compromise, which continues to be negotiated by American painters, between the accurate, convincing images demanded by a practical society, and a deep distrust of the means by which those images had traditionally been rendered. As a result, New England portraits, although they aspire to no religious purpose, share, with ancient, flat images in marble or mosaic, an aversion to worldly ease and, in their execution, an almost magical certainty. Their fixity and patterned flatness are not far from the archaic splendor of New England stone cutters whose ancient symbols and pure line, in work like the angel on the gravestone of Benjamin Wyatt (plate 15), done in 1767, still reveal a kinship to ancient icons.[1] It may be said of these artists, and of John Bull who cut this stone, that they looked upon their craft as Thomas Hooker looked upon sin, "(1) clearly; (2) convictingly— what it is in itself and what it is to us, not in the appearance and paint of it; not to fathom the notion and conceit only, but to see it with application."[2]

2. The Landscape

*When skepticism had depopulated heaven, and the
progress of equality had reduced each individual to
smaller and better known proportions, the poets, not
yet aware of what they could substitute for the great
themes that were departing together with the
aristocracy, turned their eyes to inanimate nature . . .
Some have thought that this embellished delineation
of all the physical and inanimate objects which cover
the earth was the kind of poetry peculiar to
democratic ages; but I believe this to be an error,
and that it belongs only to a period of transition.
I am persuaded that in the end democracy diverts the
imagination from all that is external to man
and fixes it on man alone.*

Alexis de Tocqueville
Democracy in America

Along with the religious motivations which drove our colonial painters to their sidelong approach to the human figure were the visual facts of their environment: a rocky, barren soil and a high, bright sun which beat down upon wooden buildings, many of them thrown up in imitation of English stone, but in detail as crisp and unmindful of the sculptural qualities of the baroque as were the portraits. In the sharpness of the portraits, one senses the play of shadows falling crisply on white clapboard, and, in Copley's whites, some of that whiteness. "I would give a thousand pounds sterling," Sir Joshua Reynolds once said, "that I could paint white like Copley." But beyond the linear architecture built around tidy, fenced greens, was the omnipresent, unpeopled landscape, and, just as the buildings and man-made boundaries marked a small, tight measure of control over it, so did the portraits.[3] Flat, in no space at all, or painted with rigorous certainty into an unshaped void like the land itself, the figures stand, almost protectively, against this vastness.

American art cannot escape its physical environment. Unlike the European countryside, where growing things have been plucked out, trimmed, walled, or hedged through generations of husbandry, and unlike European cities laid out for pedestrians' leisure with vistas surprisingly revealed and comfortingly terminated, our environment was not, and has not yet been, brought under human control. In the east, scraggly second growth presses in upon what was once cleared; in the west, fields reach endlessly toward the horizon. Even our cities, though the works of men, are essentially hostile, their avenues immeasurable to the eye and their buildings touched, like our natural landscape, with the sublime. The process, first of clearing and populating, later of building, destroying, and rebuilding, has had a relentless velocity which further denies America and American paintings the look of completeness. Understood both in the original fact of its natural extent and the continuing fact of the changes being worked upon it, the American landscape is the great protagonist of our art.

Not all the pictures painted by Americans, nor all those painted in America or about America have been touched by this unique physical complexion. In the decades when the wilderness to the west was beginning to produce less fear than promise, a new generation of ambitious painters went abroad in search of a richer style than they could find in the lean portraits of their

forebears. Trumbull, Allston, and Morse were well-educated young men, fired by a noble vision of the art of painting; the Renaissance had caught up with them. But between their thoughts about painting and the canvas itself was the terrible obstacle of their impatience. With them, as it had never been for the colonials, art was more an idea than a craft. In London where, by old habit, they sought the grand style, they could find few models and little tutelage. Even Benjamin West, who counseled them, had himself gone too fast and too far for his meager talent. "Finish it, sir, and you are a paint- er," he told Morse on first sight of his *Hercules*. What these men found was a style without its substance, as West himself and even Gilbert Stuart had al- ready done, and other *émigrés* were later to do. Their impulsive idealism, per- haps an unrecognized legacy of an older prohibition, kept them from the real meaning and the real labor of their vocation.

For all of them painting was, as Morse put it, "a cruel jilt." Trumbull was the first to taste disillusionment: he attempted to remind Americans of a war many of them would rather forget by painting battles of the Revolu- tion that were animated portrait galleries with no real collision of combat. Allston, following the advice of Stuart—who, in his own paintings, rarely got below the second button—changed the whole perspective of his *Balsha- zar's Feast*, and worked through long years on this huge composition, so ill- suited to his temperament and ability. And what did Vanderlyn, with his Parisian neo-classicism, hope to give the American public in his *Death of Jane MacCrea* (plate 16), with a heroine who succumbs, like a tragedienne, to his Borghese redskins? In France, neo-classicism could teach a people, young in the arts of self-government, the stoic lessons of an earlier republic. But here there was no past; in America, the republican lessons had already been put to work. Democracy, conglomerate and diffuse, lacked the outward fo- cus of monarchy: it was not centered on people of colorful and special as- pect; it had no residence. Like the landscape, democracy had to be felt in- wardly. For these reasons, history painting, already moribund in Europe, died here before it was born. Morse, the most embittered of these misplaced artists, came no closer to painting great history pictures of the Republic than a genre-like painting of the House of Representatives; and his search for the grand style ended with a picture of the *Grande Gallerie* of the Louvre, crowded with masterpieces he could no longer even try to emulate.

Our landscape painters of the nineteenth century, on the other hand, aspired to little, but eventually achieved much more. Like Emerson's true lover of nature, they had to adjust their inner and outer senses to each other, absorbing the essence of the place as they discovered it visually. At first there were only views of towns and comfortable villages, like those by Francis Guy, in which the buildings had already done the painter's work, ordering the landscape with the thin, spare forms of their wooden architecture. In the early decades of the century, there were also marines and landscapes, (all relics of an imagined sublime borrowed from Salvatore Rosa, the elder Vernet, or the young Turner); or paintings where the sublime had been found in the obvious places (pictures like Trumbull's, Vanderlyn's, and Morse's *Niagaras*). But, as their ways of seeing and feeling became one, the painters learned to do without topographical oddities, and their work began to reveal the awareness, expressed by Emerson, that the land itself was the "commanding and increasing power on the citizen, the sanative, Americanizing influence."

The painter-reporters—Audubon, Catlin, Miller—who went inland rather than abroad, and who pursued facts rather than ideals, came closer to the reality of the American landscape. Their pictures document the appearance of Indians, buffalo hunts, and, more incidentally, the western mountains and rivers where they found these subjects. Their interest, however, was principally in the curious: strange flora and fauna, the customs of the Indians. If they came closer than their idealistic and ambitious eastern contemporaries to creating an American landscape, or a truly American art, they did so not because they painted with reportorial realism, but because they looked upon the landscape as strangers and travelers with a vision untempered by experience or love. Their experience of the alienation of the painter from the deep bonds which bind men to the land on which they live is the essential experience which invests the work of our landscape painters.

As our painters learned to accept this fact, the plains and mountains of the real frontier became only its symbol; and their overpowering distances began to invade the soft valleys, salt marshes, and great sea beaches of the East. The nature of our landscape cannot then be found in pictures of the real frontier, but in the way our painters treated the whole face of America, and that nature was revealed to them when they had learned their neces-

sary role in relation to the shape of the space, and the things and people in it.

We can see this awareness most precisely in the work of Thomas Cole where, for the first time, a uniquely American experience of the landscape becomes evident. It is surprising that Cole painted such pictures at all, since his ambition went far beyond the modest role of landscape painter and his interests were in part literary. For him, the wilderness was a place where one "might yet speak fittingly of God," and where, in a decayed tree trunk or in the pale shoot of a young plant, one might instantly comprehend the constant process of inchoation to which he belonged and by which he would ultimately be claimed. These concerns of Cole's are represented by Durand's memorial to the painter, *Kindred Spirits* (plate 17), which shows the painter and his literary muse, William Cullen Bryant. Here, as in their writing, the forest is only a pretext: the content is primarily intellectual, and both the title and the sentiment are borrowed from Keats.[4] The spot where Cole enjoys this "sweet converse of an innocent mind," with its outcropping rock and its brook, is so clearly "Nature's observatory" that its real presence is lost. We are shown a joint meditation, the product and not the cause.

How could Cole turn his eye so expertly on real nature that the process of growth and decay, change and constancy, which engrossed his mind would find their exact visual signs? How could the public be made to see eternity in a static, factual picture of an American forest? Had he been a Constable he might have painted change itself, where it could be seen happening in the swift play of wind and weather—but his brush was too timid. He consoled himself by writing poetry in which he could more easily shift from description to comment. But in painting his grand ideas could best be worked out in cosmoramas like *The Course of Empire* (plates 18, 19) or *The Voyage of Life* (plates 20, 21), where in series of pictures he could represent, through time, the life of man or of man's works. The landscapes in these ambitious series are subjected to his speculation. The first scene of *The Course of Empire* is a landscape just emerged from chaos, heaving and tossing like a sea; the *Pastoral or Arcadian State* (plate 18) is a placid scene derived from Claude Lorraine; and the last scene (plate 19) is a melancholy, but conventional, ruin, claimed by the returning wilderness. In *The Voyage of Life*, the stream which bears the voyager turns from a brook to a torrent and finally runs into a benighted sea; the spring flowers along the shore become a dark,

exotic forest, and finally bare rock. In these Cole worked not from nature but found, from his time-haunted imagination, appropriate natural signs to express, in the triumph of nature over man, their ultimate unity. Nevertheless, he knew that he was achieving this expression only on an allegorical level, and that the gaudy, papery flowers, the improbable growths and black water he painted left real nature inviolate. Cole did not, as it has been claimed, decline into allegory; it was possible to him at any moment of his career. Even in his early scenes from Cooper's novels, he set down tiny actors among needle-sharp rocks in a fantastic, symbolic wilderness, like those the early Florentines gave the hermit saints, a wilderness outside of time, not an American forest.

It is surprising that, with his literary ambition, Cole contributed to the creation of an American landscape school at all. That he did so is due not only to his careful distinction between landscape of the imagination and landscapes of fact, but also to the growing pressure of public demand for the latter. He did not succeed in all his realistic landscapes, but in *The Catskill Mountains* (plate 22), he painted a wilderness as he saw it (or nearly so) and also, out of his realism, he expressed a peculiarly American relationship to his environment and to his art. There are no paths in this forest, no framing elements, no ground plane meticulously subdivided into foreground, middleground, and background. The mountain's concave slope does not emphasize its solid, rocky mass, but rather enframes a vast bowl of space into which the viewer is instantly projected. To be sure, Cole's mountain is more rugged than any he could have found in the East, but this admission of the "nervous rocky West" serves the image of space and reflects, in an otherwise realistic picture, an awareness of the totality of this American experience. Instead of using complex allegories, Cole conveyed his religious melancholy simply by painting a place as though it were being seen for the first time. Constrained by the traditional devices which order and make habitable a Claudian landscape, or treated with the painterly bravura and elisions found in a Constable, his forest would lose its innocence, and its strangeness would be brought near by Art. It is still a place where one might speak fittingly of God; but stronger still is the effect of an alien emptiness which separates its factual rendering from real experience. Here is the dual way of American landscape to come, the painting of a scene both convincing and

remote, dangerous and innocent, mundane and sacred, uninhabited yet habitable—offering, as Cole put it, the promise of futurity.

Among mid-nineteenth-century American landscape painters—the so-called Hudson River School was not a school nor even especially devoted to the Hudson River—are a number who, like Cole, succeeded in portraying the landscape not only as it looked, but as their awareness of its awesome extent, its remoteness, its innocence, its promise compelled them to paint it. Their realism was the perfect tool of their unexpressed intention and kept them from molding its unshaped vistas into comfortable refuges, as their European contemporaries of the Barbizon School often did. They avoided, too, showing the inroads of civilization, events, or—even more than is generally realized—a bizarre or overtly picturesque topography. Those who did not do this almost invariably compromised with traditional methods of landscape painting: Durand and Doughty most consistently. Doughty's *In Nature's Wonderland* (plate 23) shows his respect for convention; its carefully framed, hospitable space, the shape of its sky and water, the benign, golden light all combine to create a wonderland where the wonder belongs to Doughty and to Art. Events, including figures in the act of contemplation and the invasion of productive husbandry, come rarely and late. Inness' *Peace and Plenty*, painted in commemoration of Appomatox, is a celebration out of place in the fabric of our landscape art, foreshadowing some of the vainglorious regionalism of the thirties. But generally, nothing is allowed to deter the viewer from contemplating the simple fact of the land's existence in its unshaped state, and from speculating upon the form it may one day assume.

The magnificent views offered by American scenery were popularly shown in panoramas whose influence can be seen in pictures like Kensett's tiny *View Near West Point on the Hudson* (plate 24). Here, almost despite the painting's size, the viewer is kept even further from the scene represented; there is no central, stabilizing mass and no view through the picture. Instead, the headland and the range of hills behind it seem to move across the painting, remote and indifferent like the great river, past the spectator, up to the edge of the canvas, implying their extension into vast spaces beyond. The foliage and the water are all surface so that the viewer cannot feel his way into it as he might in a European picture like Corot's *A View Near Volterra* (plate

25) in which the French artist constructed a solid architecture of rocks and even of foliage to measure the deep space. In other European pictures, closer in their openness to Kensett's, like Courbet's *Seascape* (plate 26), a luxuriously painted surface is offered for its own sake, establishing with the observer an immediate material bond, more immediate and tactile than optical. In the American picture, where the scenery rolls past the viewer and the paint is entirely taken up in the creation of the image, he cannot enter, nor can he enjoy paint for itself; he can only *see*.

By 1867 the pre-eminence of our landscape school had been recognized at home, and in that year landscape painting dominated, through official policy, the American section of the great international exhibition in Paris. European critics, seeing only the labored surface of these pictures, found little to commend but "patient work and steadiness of treatment." Lacking any experience of America, they could be expected to see nothing more; but an American critic, M. D. Conway, writing in *Harper's Magazine*, was perhaps the first to detect "that vastness and loneliness which are continually impressing the imagination of the American artist."[5] This was possible at Paris where American landscape in quantity could be judged in the context of all Western painting. The loneliness Conway sensed in these pictures was a product not only of the unmanageable distances American artists painted, but of their technique as well—the uncomposed space and dogged realism which kept the viewer out of the scene portrayed. But since such a mood was beginning to invest the work of all our painters, it is likely that the landscape had become not only a cause of physical loneliness but also a symbol of the more pervasive loneliness produced by the moving, unsettled structure of American society. The innocent Eden of Cole had found a secular corollary.

Indeed, at Paris were to be seen painters who stressed either one or the other of these aspects of American landscape experience. On the one hand were Bierstadt, Moran, and Church, who were led farther and farther afield in their pursuit of untouched innocence; on the other hand was Kensett, who seemed compelled to find a dehumanizing, unyielding objectivity in his strange picture of the bare rock and water he found near at hand.

In the first group, the earlier, quasi-religious attitude of Cole was lost in the grandiloquence of Bierstadt and Moran who, with techniques polished by European study, gave to their pictures the appearance of carefully re-

corded fact when, actually, they were dramatic topographical generalities culled from a variety of sketches made in a given area. This practice led engineers and surveyors to scoff at their science, and caused Henry James to remark that one of Moran's pictures gave "an uncomfortable wrench to our prosy conception of the conduct and complexion of rocks, even in their more fantastic moods." But Church's paintings and his travels suggest that he retained from his teacher, Cole, some conception of the landscape as a holy place.[6] What Cole could find, however, in the Catskills or Adirondacks, Church was impelled to seek in voyages which took him unerringly to the edges of civilization: to South and Central America, Mexico, and the West Indies, to Labrador, and later, carefully past Europe to the spiritual homeland of Western civilization, to the Holy Land and the Acropolis of Athens.

His *Heart of the Andes* (plate 27) is an Eden, now more remote than ever. The exotic growth Church really saw resembles the fantastic settings Cole imagined for his *Expulsion* or the opening scene of *The Voyage of Life*. Church's admirers could only look at it from afar, counting its leaves through their binoculars. Perhaps this remoteness measures a withdrawal of the promise Cole felt. Indeed, there is a touch of pathos in Church's endless travels, and one wonders if there came to him a bitter knowledge that, in the end, there was nothing—if, while chasing icebergs in the North Atlantic, he too saw, in the beauty and terror of their ineffable whiteness, the White Whale, Ishmael's "snow hill in the air."

Unlike these indefatigable travelers, Kensett limited his painting trips to the usual rounds of eastern mountains and shores. However, the note of elemental barrenness which embitters some of Church's work, Kensett struck on the rocky beaches of New England. His *Cliffs at Newport* (plate 28), which appeared at the Paris exhibition, is, in a less spectacular way, as dangerous and as remote as Church's icebergs or *Rocks off Grand Manan Island*. Under a harsh, American light, Kensett explored the unpromising surface of bare rock seen against a sea on which a few sails are the only evidence of summer recreation. It is a bleak, brilliant picture, producing an almost surrealistic effect in its searing clarity. In it the painter asserts that unassailable otherness of the American environment in a way that can perhaps best be described by Wallace Stevens' observer, who, "nothing in himself, beholds nothing that is not there and the nothing that is."[7]

By the end of the century, a new wave of influence from abroad came into our painting, this time from France. It brought the end of our native landscape school. The realism of the older artists, learned by many of them in Düsseldorf, had been a perfect instrument for comprehending the American landscape, but in the late decades of the century, our painters became increasingly disenchanted with its fussiness. Alexander Wyant, dissatisfied with what he found in Germany, began in the late sixties to load his canvases with paint; Homer Martin, in the eighties, changed from a style modeled on Kensett's to one learned from the Barbizon painters. Finally, Weir, Twatchman, Robinson, and Hassam brought to America a pale, belated impressionism which gave their pictures—despite a supposed devotion to particularity—only a vague, unlocalized prettiness, while Blakelock, and Inness in his late years, lost the unique look of America in poetic landscapes of mood.

Archibald MacLeish has written that "an art is something which requires an artist living in a land. It is something between a man and the earth he lives on. It needs an understanding and it takes time . . . for a new people and a new land to understand each other . . . an understanding by habit, by repetition, by expectation, by use . . . most of all by use."[8] Only then, he claims, can a new country have an art of its own. But American art was not born out of this union nor is it likely to be reborn. What was truly American in our nineteenth-century landscape, as in our nineteenth-century novel, was shaped precisely by the absence of mediating custom, habit, and use: there could be none. Its reality, as Lionel Trilling has written of our literature, was only tangential to society.

3. The Figure in Space

And you O my soul where you stand
Surrounded, detached in measureless oceans of space,
Ceaselessly musing, venturing, throwing, seeking
 spheres to connect them . . .

<div align="right">

Walt Whitman
Leaves of Grass

</div>

American genre painters of the nineteenth century—Quidor, Blythe, Mount, Bingham, Eakins, and Homer—painted, with patience and honesty, pictures of people in familiar surroundings. They were not, like Courbet, realists of the opposition, convinced of a necessary social mission, nor did they have Courbet's power to endow the commonplace with the dignity of a new, popular history of the anonymous. Their innovations—Mount's portable studio or Eakins' personal perspective—were devices to bring them closer to things as they were. In none of their pictures is there apparent that transformation of the real which makes the label, genre painter, meaningless when applied to Gericault, Manet, or Van Gogh.

Like the little Dutch masters of the seventeenth century, the Americans were true genre painters. Bingham and Mount painted when America was beginning to grow, expanding aggressively in the West, when the cities were filling with immigrant laborers and sooty factories. Their quiet paintings touched a responsive nostalgia which made Mount's country people and Bingham's rivermen popular in the exhibition rooms of New York; their paintings had begun to express what America was not, to convey a sense of loss which later, in the work of Eakins and Homer, became a deeper, almost tragic, melancholy. In one sense, the rural aspect of their pictures was a form of escape. This escape is evident in more than the locale or setting of their pictures: we are given not just the country instead of the city, but also leisure in place of labor, passivity in place of action, still Sunday afternoons beyond the pressure of time. In Mount's most popular pictures, this theme of idleness and passivity is expressed directly or by implication: an angry farmer rouses napping farm boys, a colored field hand leans against a barn door bemused by a fiddler, a young boy drifts with a stout Negress spearing eels on a salt river in Long Island (plate 29). Bingham's rivermen glide down the somber Missouri or simply watch and wait, immobile, as Eakins later painted his friend Max Schmidt on a luminous bend of the Schuylkill. The artists and their painted figures seem to have heard Emerson's invitation to those "drenched in time, to recover themselves and come out of time and taste the native sweetness of their immortal air."

But these persons, too, are set down in an American space which, like the space of our landscapes, remains masterless. Mount's eel-spearers drift across the picture. Their effortless movement is reinforced by the shore be-

hind them, a shore which stretches across the picture, arrested at the edges only by short, pointed trees and their reflections. This void of sky and reflecting water is controlled not by the figures but by the long spear and steering oar which reach upward and, by reflection, downward, denying the plane of the river and forming only a thin, linear construction to control space without really invading its emptiness. Bingham uses a similar device in his *Fishing on the Mississippi* (plate 30) where a long pole extends to the top of the picture and another reaches, with the shore, in a thin arc to the flatboat far downriver.

A similar, but more complex geometry governs Eakins' *Max Schmidt in a Single Scull* (plate 31), causing the picture to retain the careful, linear skein of his perspective studies. Here, as in Mount's picture, the figures are suspended in a luminous void of sky extended by reflection, a void controlled not by the figure but by slender, weightless means which provide a pictorial organization and yet leave the power of the setting to work independently. The water, its surface dissolved by reflection, is cut by parallel and converging wakes of shells and trailing oars. One cloud, a mare's tail, bright white in a clear sky, forms a linear echo to the scull, uniting, but not joining, sky and water. The figure and its environment are never one.

The disjunction is also true of the larger, more commanding figures which people the great reaches of river in Bingham's pictures. There is nothing of Mike Fink in the rivermen who appear and reappear in them. They are gentle, genial men who, by their nonchalance, their dancing and their gaming— never by their labor—state their familiarity with the slow river. Peering out of the mist, in *Fur Traders Descending the Missouri* (plate 32), they confirm the ghostly reality of their setting or, grouped classically and isolated against the sky, in *Raftsmen Playing Cards*, they intensify the great space which falls away behind them. Bingham's best figures are always still and purposeless. When he sets them dancing, or paints Daniel Boone leading a band of pioneers into the West, they become stiff and theatrical. He could paint solid objects with his still figures without destroying or making comfortable the great distances which were their element. In *Watching the Cargo* (plate 33), the boatmen sit on a mudbank by some goods, motionless except for one who blows life into a driftwood fire. In the distance, the stranded steamer and, on the right, a piece of driftwood, edged in light and assertive despite

its size, hold pictorially against the other castoffs of the river. They form points of a triangle across and back into space, its bulk on the left reduced yet balanced on the right by a single, apotheosized piece of driftwood, so that, just there, reaching to and beyond the steamer, the river can be seen and felt. So it is that in the stillness of Bingham's quiet figures resides the silence and composure demanded by the river. Their environment dominates them, not they—despite their size—it.

Eakins' *Pushing for Rail* (plate 34), more realistic than Mount's or Bingham's pictures, shows a flat salt marsh under an empty sky. In this monotony the small, red-shirted hunters, the pushers and their poles, and the sails on the unseen river provide but minimal control over the emptiness and the natural disorder which, for the realist, is the condition of seeing. Composition, as it was understood in more traditional academies, was not even taught at Eakins' school,[9] and neither he nor his contemporaries followed the impressionist's way of softening the stark encounter of figure and ground with exotic patterns or a unifying envelope of colored light.

These pictures are technically genre painting but, since their primary concern is with the relation of figures to the land, they are also landscapes. Ultimately they are more meaningful as such, for the people in them, unlike the token figures in landscapes, help to convey the total experience of a place. Their compositions of fine-spun lines drawn or implied through space, in a way, parallel the light, flexible locomotives and slender bridges which were spanning our continental distances. But, as with the engineering, the more efficient those patterns became, or the farther they leaped, the more impressive became the force of the distance to be overcome.

The last decades of the nineteenth century were marked by a booming expansion of American industry and, in our painting, by a surge of academicism. The captains of industry supported this wave, either because they mistakenly saw in its sentimentality an inflated "nobility," the morality of great art, or because they found in it a badge of status that their profitable commerce could not alone produce. Like all American painters who have tried to Europeanize their style, La Farge, Hunt, Brush, Thayer, and a host of others now forgotten found only the empty shell of a historical style long since deserted even by the Europeans.

Our greatest painters of these post-Civil War years were the realists:

Eakins, Homer and, more than is generally realized, Eastman Johnson. With them should also be named Sargent at his best and, perhaps, Albert Pinkham Ryder. These artists brought no revolution to our painting, as is sometimes claimed, but only the *appearance* of revolt in their stand against the new wave from Europe. Instead, they continued to express, now more consciously because they could see what their more pretentious contemporaries were doing—or rather, not doing—the experience of America which had, half detected, invested our earlier pictures. As the realists probed farther into the appearance of things and found new subjects, the deepest drives of American art became more apparent, more strongly, rather than differently, stated.

In contrast to the new world of experience and symbol created by the French post-impressionists, the realists' objectivity was as dated as the Renaissance yearnings of the academic painters. If one were to find any formal analogies between the Americans and the most advanced French work of the eighties or nineties, one would have to look in the twisted contours and symbolic devices of Ryder and perhaps find something vaguely reminiscent of Van Gogh or Redon. Ryder did experience a revelation when he saw nature with "no detail to vex the eye," threw his brushes away, "squeezed out great chunks of pure, moist color" and, with his palette knife, laid on "blue, green, white, and brown with great sweeping strokes. As I worked," he wrote, "I saw that it was good and clear and strong. I saw nature springing to life on my canvas, but it was better than nature, for it was vibrating with the thrill of new creation."[10] Had he been really able to accomplish this, Ryder might have matched Gauguin or Van Gogh, but too often his pure colors grew dull with reworking and, instead of creating a new and perhaps more congenial world with confidence in the power of his art, he found only a way to express his own, self-defeating loneliness. The boat, in his *Toilers of the Sea* (plate 35), escapes outward toward the dark horizon and upward toward the moon isolated above it with a cloud in a compulsive pattern of American discontinuity.

The more one studies the inner meanings of Eakins, Homer, and Johnson, however, the shallower Ryder's pictures seem to be: the more dependent on literature and the more heavy-handed his evocation of his single—if genuinely American—theme of lonely isolation. All that binds these artists to the post-impressionists is a response to the pressure of the modern world,

which produced, both here and abroad, the now familiar sense of bewilderment, uprootedness, and loss of identity. Indeed, the declining importance of the human image in the whole history of modern painting has been interpreted in terms of this loss, a loss that had been foreshadowed in the unsettled conditions of America where an awesome geography, a fluid society, and untried institutions had already conditioned its imagery. But Europeans believe in art as Americans have never done. The paintings of Cézanne, Van Gogh, and Gauguin represent heroic efforts to make external reality yield to the artist, to create a more coherent unity than the real world could offer; the radical means they found to do this was a measure of their dissatisfaction with things as they were. The Americans, with little faith in the power of their art, and no means which they could trust but their patient, watching realism, remained passive. Present, but seldom noted in their work, is yet their own note of bewilderment and loss.

This sense of deprivation can be seen in the almost oppressive seriousness of Eakins' portraits, in the disarmingly simple genre of Eastman Johnson, and in the swing of Homer's subject matter away from fashionable young ladies on a shore, to frozen seascapes. It can be seen in Johnson's abandonment of the popular geniality he had shown in *Old Kentucky Home,* for the haunting seriousness of his post-Civil War pictures like *In the Fields* (plate 36), where berry pickers are fixed on a Nantucket moor, in rapt contemplation of nothing at all. Similarly a disturbing irresolution invades the apparently simple domestic incident set out in Johnson's *Not at Home* (plate 41). In its shadowed foreground a young girl scurries from a suite of rooms, leaving inanimate objects—a chest and baby carriage pressed to the edge of the deserted space—to take on a disquieting significance. The story, such as it is, is of something that does not happen, told in a vacant space.

Between these men and their European counterparts the differences we have noted persist. Courbet painted *Mère Grégoire* (plate 37), the round, jolly proprietress of his favorite *brasserie,* with boldness, striking in the great mass of her head with a confident brush. The black bulk of her figure, placed centrally in the space of the picture, overwhelms its surroundings: the marble counter, the flowers—roughly brushed yet rich in detail—and the tiny flower held incongruously in her great, fleshy hand. Here one can weigh the splendid fat of the baroque tradition and even sense, behind the

figure with her upraised hand, the solid, disporting nymphs of Titian or Veronese. Mère Grégoire's contemplation of her flower has a concreteness typical of the whole picture. Eakins' *Miss Van Buren* (plate 38), on the other hand, sits in vacant apathy, her eyes turned toward the light source beyond the edge of the picture. She cannot create, like Courbet's matriarch, a space around her, for she has no energy, literally depicted or plastically generated by her position in space. She slides back into space encompassed by an enormous chair—the only spatial construction in the picture—overcome by its physical presence. Its tall back and padded arms thrust forward into space, exerting more force than her whole figure. Here, as in other portraits—*Katherine* or *Lady with a Setter Dog*—Eakins blunts his realism by drawing his sitters into psychological abstraction, and, once again, the environment saps the vital presence of its people.

Eakins does this also in the portraits of his friends, professional men whom he, as a realist, felt compelled to paint at their customary tasks. Thus: scientists sit amid their apparatus, doctors discourse in operating rooms, a dean calls the role of his students, a thinker thinks. In every case the "sitters" are saved by their labor and by their absorption in it from the self-conscious posing of the studio. As Fairfield Porter has suggested, they seem to apologize for being painted at all.[11] Eakins' figures, engrossed in what they are doing, take no cognizance of the viewer who remains cut off from their world. Thus, *The Thinker* (plate 39), hands thrust in his pockets in an attitude typical of American casualness, wearing a rumpled suit, is not posed at all, and is totally unaware of anything beyond his own thoughts. Courbet's splendid portrait of his friend, the poet Max Buchon (plate 40), is, like Eakins', a simple contrast of dark shape against a neutral background. Both of them may in fact be derived from Velasquez, whom Eakins particularly admired. But Courbet's figure is suavely contoured, and the jaunty, almost arrogant pose, derived from the tradition of court portraiture, marks a strangely aristocratic intrusion into Courbet's egalitarian milieu. In Eakins' portraiture, the inherent paradox of American realism is clearer than ever—because his realism is profound. His figures are ultimately less real, however, than more traditionally painted ones where the figure sits, alive to the fact that he is being looked at, in physical command of the space around him, and further enlivened by the independent vitality of the artist's brush as it paints him.

Sargent, despite his transatlantic success, invested his early portraits with an American aura of detachment, not by his loose, painterly brushwork, but by the open, evocative settings he gave his sitters. In *The Daughters of Edward Darley Boit* (plate 42), the children are stationed near huge vases, which give them a children's scale, far back in a deep space which reaches still deeper into the darkness beyond them. Their studied placement, which might have been inspired by the *Japonisme* of Whistler and the impressionists, has little in common with the removal of Eakins' preoccupied sitters. But Sargent did not, as Whistler did, use exotic patterns simply for their aesthetic interest.[12] His sitters are separated: one by a section of wall on the left, one by an area of carpet, and two by a doorway. Each is thereby locked into the private and inaccessible world of his childhood. In his portrait of *Robert Louis Stevenson*, the poet appears like a specter moving restlessly toward one side of a bare room. Behind him on the right is a veiled figure cut by the frame, and in the center a door is opened onto space beyond. Here again the arrangement may have stemmed in part from Whistler or Degas but, as in the Boit children, it is not an arrangement for its own sake, but a special environment to define the nature of his sitters. In both pictures the composition serves his psychological insight; in both of them, the figures are lost in space.

Winslow Homer's pictures—indeed, his whole career—dramatize the lonely withdrawal and renunciation we have already observed. At first there was little hint of this in his leisured ladies and rustic juveniles. Henry James could write in 1875 that Homer's "vacant lots of meadows" and "pie nurtured maidens" were redeemed only by his ability to see "everything at one with its envelope of light and air." This gift is revealed most splendidly in the joyous airiness of his *Long Branch, New Jersey* (plate 43), which is as advanced in its rendition of brilliant sunlight and open air as are similar subjects of comparable date by Boudin and Monet. This picture and other of his early beach scenes, like *High Tide*, are typically American in their emphasis on the flat stretches of beach or bluff on which his figures stand. But in these pictures the unsheltered confrontation of figure and great reaches of shore are only recreational; their holiday atmosphere excludes any melancholy feeling of isolation.

During the eighties, however, when anecdote becomes strongest in Ho-

mer's pictures, the fashionable vacationers of the Jersey shore become the robust, anxious wives of Tynemouth, whose business on the shore is the long watch for the return of the fishing fleet; in *Undertow*, the calm, blue sea of the earlier pictures becomes dark and dangerous. Other pictures of this period—*Lost on the Grand Banks, The Herring Net, Eight Bells* and *Fog Warning*—are concerned with men at work earning a living in their daily, lonely encounter with the sea. They reflect Homer's own self-imposed isolation and his awareness of the tough, essential facts of existence which were becoming lost in the comfortable prosperity of America. In *Fog Warning* (plate 44) the dory is tossed up diagonally by the sea and played off against the parallel diagonal of threatening fog. As in Ryder's *Toilers of the Sea* (plate 35), a picture it somewhat resembles despite its narrative content, there is no framing of cloud or water to mitigate the bitter confrontation of men and elements.

Homer's late genre paintings deal even more fundamentally with deprivation, danger, and death, exemplified by the patterns of cold color that dramatize the struggle for survival in *Fox in the Snow*. Similarly, the huntsman of *Huntsman and Dogs* (plate 45) stands against a bare hill and gray sky. His foot rests on a gray, dead stump, and blood from a fresh deerskin he carries attracts his leaping, barking hounds. *In the Gulf Stream* (plate 46), a picture which proved no more salable than *Huntsman*, depicts a helpless Negro adrift on a derelict sloop, threatened by hunger, thirst, exposure, by a waterspout and pursuing sharks. It is a strange sequel to Copley's *Watson and the Shark* (plate 13) and Gericault's *Raft of the Medusa*. There is no action; no signal to the distant schooner promises rescue. Instead, the relaxed pose of the castaway and his almost casual glance toward the waterspout establish an uneasy tension between the tossing, violent sea and its passive burden. The Negro drifts like the water-borne figures of Mount, Bingham, and Eakins, but now on an ominous sea. "Don't let the public poke its nose into my picture," Homer wrote to its first exhibitor. This remark was prompted by the fact that the picture was not quite dry, but he may have intended a larger meaning. There is something evasive in his letter explaining that the picture was only intended to capture the appearance of the Gulf Stream as he remembered it. Although he insisted that the shark and the derelict were "outside matters, of little importance," it is not impossible to believe that in this

helpless victim, blown out to sea by a hurricane, Homer saw something of his own disillusionment with the society he had rejected.

These genre paintings are as inhuman as the bleak seascapes which occupied most of Homer's late years as he turned from the human figure to look, like Cole's aged voyager of life, on the mindless collision of water and bare rock. His whole career, his personal withdrawal to Prout's Neck on the Maine coast, and his steady progression to ever more basic subject matter, epitomizes the history of our late-nineteenth-century realists. With a melancholy seriousness common to all of them, he found narrative means to specify the sense of flight and loss which pervades the portraits of Eakins and even Sargent, and the genre scenes of Eastman Johnson. His seclusion on the Maine coast parallels the journeys of Church to the edges of civilization. But for Homer there was no innocence left in nature and he turned into an active, hostile force, the uncontrollable, inhuman elements which Kensett had begun to see in the rocks and sand of his landscapes. Ultimately, all of our realists felt the uncertainties of the modern world and responded with a delicate, visual poetry of renunciation.

4. The Eight and After

*Of course an over self-conscious straining after a
nationalistic form of expression may defeat itself.
But this is merely because self-consciousness is always
a drawback. The self-conscious striving after
originality also tends to defeat itself. Yet the fact
remains that the greatest work must bear the stamp
of originality. In exactly the same way the greatest
work must bear the stamp of nationalism. American
work must smack of our own soil, mental and
moral, no less than physical, or it will have
little of permanent value.*

Theodore Roosevelt
Address before the American Academy and
National Institute of Arts and Letters, Nov. 6, 1916.[13]

Only five years elapsed between the exhibition of Eight American Artists, held at the Macbeth Gallery in 1908, and the Armory Show of 1913, but these two exhibitions were totally different in what they revealed and in what they promised for the future of American painting. The Eight gathered together only for this one exhibition, and were not firmly committed to any common goals. Four of them—Luks, Glackens, Sloan, and Shinn—had learned as newspaper artists how to capture quick action. Also, they had absorbed from the teachings of Robert Henri, the most articulate of the group, some of his passionate conviction that painting must reflect the artist's total involvement with life as it is lived. The others were more independent. Davies, who organized their exhibition, tended toward fantasy; Lawson softened the impact of his pictures with a gentle impressionism; Prendergast, who developed his original style abroad, was less concerned with the realism of his subject matter than with the excitement of colored patterns. Even Glackens now seems tame, close to the impressionists and, like Shinn, not overly concerned with the seamy aspects of urban life. Today we are most likely to associate the Eight with paintings by Luks and Sloan, whose pictures of New York's lower east side tenements, teeming sidewalks, and crowded beaches came closest to the abundant, raw vigor toward which Henri had led them.

The famous revolt of the Eight was primarily one of subject matter. The shock their exhibition produced can only be measured against the polite genre and washed out aestheticism the public had become accustomed to. Their technique, particularly that of Henri, Luks, and Sloan, was derived from Munich School brushwork—with some affinity to Frans Hals and to the "black Manet." It was a technique new only in America, and not very new at that, for it had already been introduced here by Chase and Duveneck.

Henri and the four who had worked on newspapers studied at Eakins' old school, the Pennsylvania Academy of Fine Arts, and acknowledged their admiration for his work. In a general way, they continue in the tradition of American realism, but, instead of Eakins' introspective figures, they painted laughing, cavorting extroverts, and, instead of immobilizing their figures with the older, disjunctive realism, they tried to lend them the vitality of a broad, almost slapdash brushwork. The sweaty struggle of Luks' wrestlers, or the bloody violence of *Stag at Sharkey's* (plate 47) by the young

George Bellows replaced the inaction of Eakins' boxing pictures such as *Taking the Count* or *Between Rounds* (plate 48). Luks, Sloan, and Bellows all attempted to overcome the characteristic passivity of our older realism and give it an active focus. It was an attempt—necessary only in America—to prove that painting was a job for real men. But their pictures sometimes seem a little shallow, and the vitality and substance of their figures are frequently obscured, rather than enhanced, by the broad play of brushwork. They looked on the slums with none of the concern which was beginning to be felt by our social reformers, and painted them not out of protest, but out of their own abundant good nature.

The Eight's revolution was not killed by the Armory Show. With them, began a search for typically American subjects, and that confusion between American subject matter and an American style which has since beset many of our painters and most of our critics. Reginald Marsh, Guy Pène du Bois, and Jerome Myers were a few of the men who continued to paint New York with the Eight's proletarian vigor. Even the regionalists, who scorned any urban orientation, continued the same quest for significant American subjects. It is not possible to write of all those painters who, relatively impervious to the tenets of modernism, painted the "American Scene" between the two wars. We remember a great many of them because their painting, reflecting a national mood of isolationism, was, in its time, extremely popular. It was commissioned for public places and paid for by public funds, and thus widely exhibited, photographed, and recorded.

No single artist, of all those who produced this vast portrait of America, reveals its ambition and its limitations as well as Thomas Hart Benton. In vociferous rebellion against the city (a "coffin for living and thinking," as he called it) and against the sophistication of the East Coast and Parisian modernism to which he himself had first succumbed, Benton painted on canvases and public walls a heroic pageant of American life. The only style he could find for this undertaking was a supercharged neo-baroque, with tortuous contours and extravagant gestures. His figures look, as John Sloan remarked, as though they should be carved out of wood and put around a crèche; he was unwilling to pursue his instinct for life in the reality of flesh or texture, or to explore the uniqueness of things. Furthermore, the twisting contours which invest his figures and their surroundings, as in *July Hay* (plate 49), do not originate in the figures themselves, in their motions or ges-

tures, but seem to be born of a prior conviction that swirling, unattached line equals American energy.

Benton was not alone among our realists of the thirties in forgetting that there was more to creating an American art than painting the hustle of American life. Many others failed to see that, one day, pictures of a drought- and depression-ridden America might seem hopelessly dated. They also forgot, as Benton did, that the Model T, the dirigible, and Mickey Mouse might eventually evoke only nostalgia. Apparently, none of them realized that, particularly in America, the modern industrial world they could no longer neglect demanded to be treated in some form of abstraction, precisely in order to protect pictures of it from its inherent, swift obsolescence. Perhaps the political or social causes they espoused or the ephemeral hardware they painted will become neither more nor less dated than the silent, vacant scenes of Hopper and Sheeler or the abstractions of Stuart Davis. Then they will be judged, as they themselves would have it, as American painters and, therefore, on their success in creating through their pictures an inner consonance of person and place. Because no art since the seventeenth century has attempted such a celebration of human vitality, the Eight, and painters like Benton who are related to them, will also be judged on their success in painting significant American action.

Success in this is less a question of ability than of possibility. What gesture is there to paint which is not self-limiting; which one can be immediately seen to belong here? The superficial bravura of the Eight and the empty frenzy of Benton's figures suggest that there is none, and that these qualities are offered in compensation for that lack. American artists before the advent of The Eight, and many of them since, have been aware that the American stage was too big to be mastered by human activity. Mistrustful of human gestures, they have painted, instead, the human figure in silent resignation to the dictates of its surroundings, or, avoiding the human figure entirely, they have painted only an empty place where action might take place. That is perhaps why Benton and the other painters of the "American Scene" have won a less secure place in the affection of the American public than those twentieth-century Americans who found in European abstraction a way to express our own abstract relation to the land.

The Armory Show of 1913, organized by the Eight, was perhaps more important in its impact upon public taste than in its influence upon professional

practice. Although the show has become a convenient point to mark the new influences of post-impressionism, fauvism, and cubism upon our painters, in fact they required more than this brief exposure to imitate these new European forms. Furthermore, by 1913 many young Americans—such as Marin, Demuth, Weber, and Walkowitz—had already worked abroad, and, if they did not begin to study modern Parisian painting there, they found it in New York at the Photo Secession, later "291," owned by Alfred Stieglitz, a persuasive supporter of the new European painting. It is not important to describe here the disorderly approach of American artists to this new material, to specify their sources, or to examine the work of painters like Max Weber, Schamberg, or Walkowitz, who seemed drawn only to its modernity. More significant were the changes worked upon the new European painting by those artists whose primary concern remained with American subjects, and who could no more accept cubism for its own sake, than their predecessors could accept Düsseldorf realism or Munich bravura.

A number of young American painters put the new European painting to work describing American dynamism with the same exuberant spirit earlier painters had shown. John Marin used fauve color and a geometry emboldened by cubism to breathe violent energy into his paintings of New York: elevated tracks career overhead and skyscrapers push tumultuously into the sky. Joseph Stella, returning to New York, already had a futuristic technique at his command to paint its awesome velocity and newly electrified brilliance. Stuart Davis developed from cubism an abstract style to convey, with brilliant color and explosive, jazzy rhythms, the hurried, fragmented experience of living in modern America.

If these were the most predictable American responses to the new painting, there were other artists who opened up the compact structure and unified the broken planes of cubism to convey the special experience of American space. Demuth, Sheeler, O'Keefe, Hartley, and Hopper all moved away from the abstraction inspired by their first encounter with modernism and became steadily more concerned with American themes. Ultimately, they derived from the encounter a chaste, puritanical simplicity and force which enabled them to paint in the man-made, industrial landscape of steel, concrete, and asphalt the same alien indifference they and their predecessors saw in the natural landscape. Even at the beginning they were less willing than their European mentors to de-nature objects. Hartley's *Portrait of a German Offi-*

cer (plate 50) of 1914, is not a cubist picture, although it might at first appear to be one, but an assembly of flat insignia, broadly painted with bright colors, and aligned with the surface plane like objects in a *trompe-l'oeil* emblem. Hartley did not find himself until much later when, isolated in Maine, he painted its mountains and coastline with some of the old force of Homer. Georgia O'Keefe achieved her abstraction by magnifying objects, but their identity is only momentarily lost in the shock of their nearness. In Sheeler's *Barn Abstraction* (plate 51) of 1917, the image is left intact, and the picture resembles less the austere abstractions Braque or Picasso sometimes favored, than it does the crisp, clear planes of Shaker furniture—which he collects—or of certain American folk paintings: the buildings, for example, in Hicks' *Residence of David Twining, 1787* (plate 52).

French cubism, the primary source for these painters, was the flower of a long tradition, a flower which could not easily be picked. It required not the knowledge of a place but the knowledge which only a long tradition of painting could supply. Although it was the result of a profound inquiry into the nature of art and reality—no matter how radically cubist pictures asserted the primacy of art over the material world—their self-sufficient order and resonant color kept faith with the great tradition of European painting. Compared to the solid structure of Braque's *Houses at L'Estaque* (plate 53), the planes of Demuth's *Trees and Barns, Bermuda* (plate 54) seem thin and transparent; the lines which define them, crossing and recrossing the picture surface, seem spun like a web to embrace concretized light and to link one object to another—binding solid and void in one light-filled atmosphere. Despite these devices, objects remain in place as the painter found them. Braque's concern was with creating a new unity of solid things and he moved them about at will. In Demuth's later picture, *My Egypt* (plate 55), the grain elevators are more strongly asserted than the trees and barn of the earlier painting. The twin commercial colossi, though linked to the sky by similar planes and lines, are unmistakably there to express Demuth's wry comment on the nonexistence of an American past.

Charles Sheeler relied less than Demuth on a personal abstract style, but his immaculate, finished surfaces, like Demuth's precise geometry, create an effect of psychological detachment. In his later pictures, like *American Landscape* (plate 56), he painted the industrial landscape with unnatural clarity. The composition, recalling that of our nineteenth-century landscapes, is

governed by a long foreground horizontal, reaching across the picture, inter-
sected by the vertical chimney, and by the loading machine and its reflection.
This pattern does not enclose or frame the space of the picture. Nothing
moves; for Sheeler, with a subject before him that might have symbolized
American industrial might, painted, instead, all that it was not, as before him
Mount, Bingham, and Eakins had painted their sunlit images of idleness.

Edward Hopper need never have seen cubism; in the empty cities, he
painted the geometry already there. His cityscapes, lit by dim night lights
or by the cold, early morning sun, are as inhospitable and as remote as the
prairies. In long shadowed paintings like *Early Sunday Morning* (plate 57)
or *Manhattan Bridge Loop*, he surprised his subject as Sheeler did, to paint
only stillness and emptiness. In the former picture, variously curtained win-
dows, arranged by unseen hands, and, in the latter, a lone figure moving off
to the left, only intensify the vacancy of the space, which, by long horizon-
tals of track and pavement, is seemingly extended beyond the edges of the
pictures. In his famous *House by the Railroad* (plate 58), rusty, unused
tracks encroach upon the house, cutting it from the ground and from any
context of its own, leaving it to loom, like Bingham's rivermen, against an
empty sky. His figures are always isolated one from the other and, in many
of his pictures, are seen through a closed window, making their space more
remote and turning the observer into a lonely *voyeur*. Figures and the inani-
mate architecture around them are treated with the same soft technique
which, like a light snowfall, seems to unify and silence the whole.

Sheeler, Demuth, and Hopper are not formalists but neither are they paint-
ers of "The American Scene" in the usual sense of the term. Although their
pictures have a smoothness and precision which speaks of machine-like ex-
actitude, their art, unlike the cubist-derived art of Delaunay, Leger, and the
futurists, does not celebrate a new machine age. Their paintings of actual
machinery are often close-ups, showing only a fragment taken out of its
mechanical context and painted in a slow, careful way which immobilizes
all. Their factories and streets, deprived of the swarming life which alone
could animate them, are revealed in their essential indifference to the human
will which shaped them. Most profoundly, their art reveals how little Amer-
icans have yet been able to contend with what they have made—as earlier
they were overcome by what they had found. In these twentieth-century
paintings, the modern world is less celebrated than exorcised.

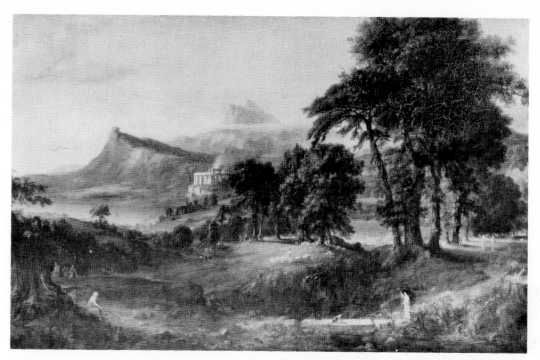

18. Thomas Cole, *The Course of Empire: Pastoral or Arcadian State*, 1836, 39 1/2" x 63 1/4". The New York Historical Society, New York, N.Y.

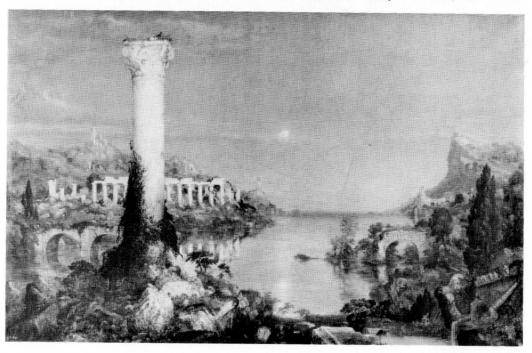

19. Thomas Cole, *The Course of Empire: Desolation*, 1836, 39 1/4" x 63 1/4". The New York Historical Society, New York, N.Y.

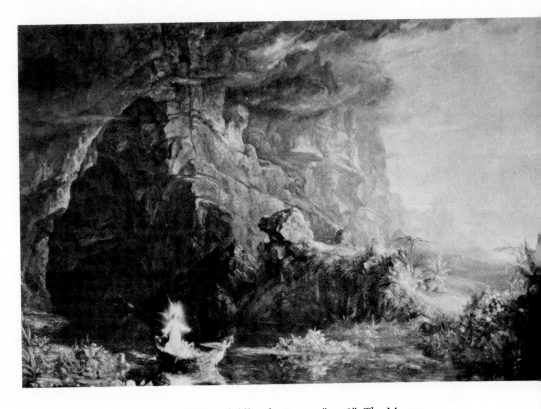

20. Thomas Cole, *The Voyage of Life: Childhood,* 1842, 52" x 78". The Munson-
 Williams-Proctor Institute, Utica, N.Y.

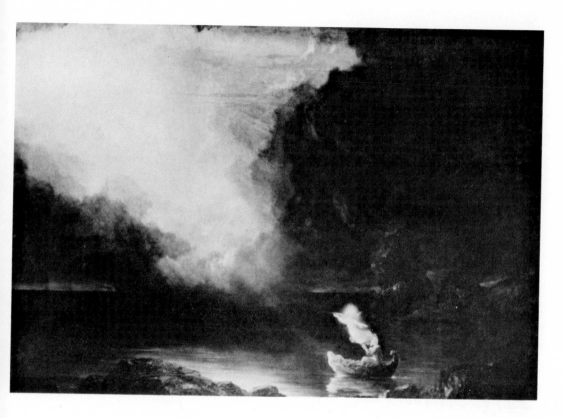

21. Thomas Cole, *The Voyage of Life: Old Age,* 1842, 52″ x 78″. The Munson-Williams-Proctor Institute, Utica, N.Y.

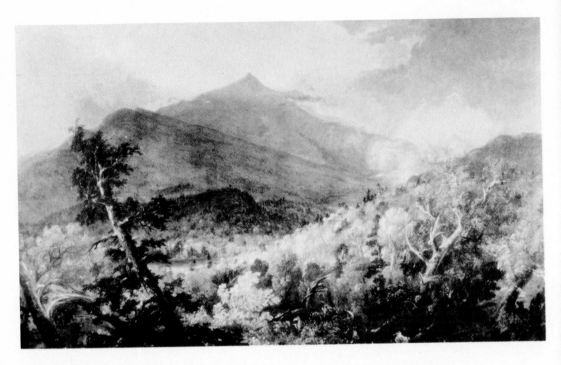

22. Thomas Cole, *The Catskill Mountains*, 1833, 39 3/8" x 63". The Cleveland Museum of Art, Cleveland, Ohio.

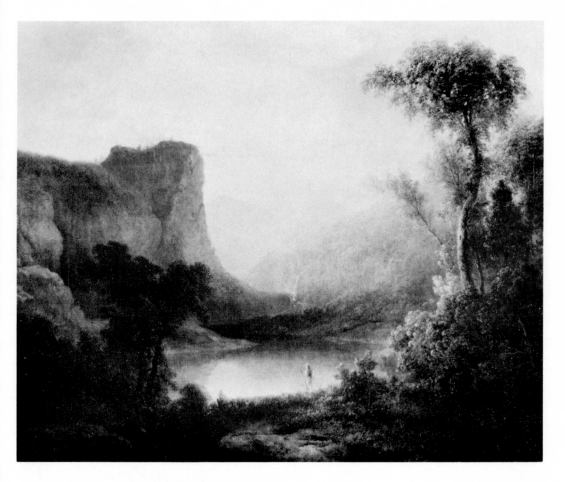

23. Thomas Doughty, *In Nature's Wonderland*, 1835, 24 1/2″ x 30″. The Detroit Institute of Arts, Detroit, Mich.

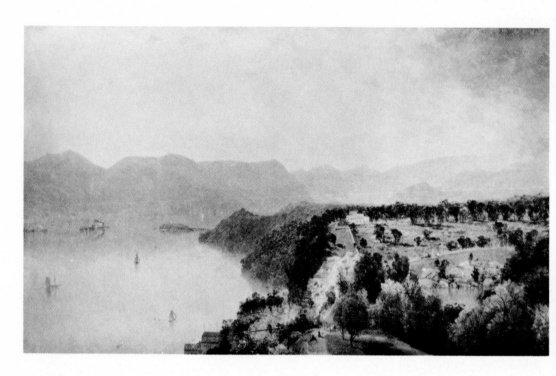

24. John Kensett, *View Near West Point on the Hudson*, 1863, 20" x 34". The New York Historical Society, New York, N.Y.

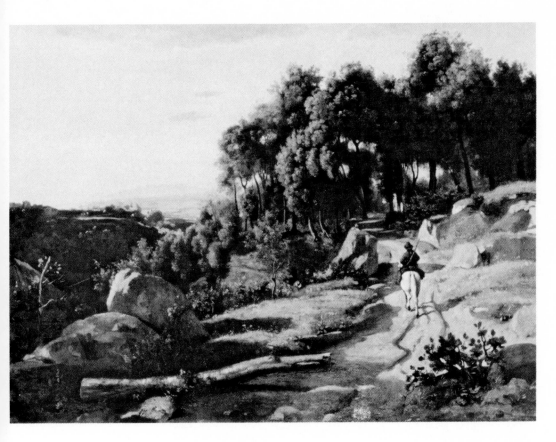

25. Jean-Baptiste-Camille Corot, *A View Near Volterra*, 1838, 27 3/8″ x 37 1/2″.
The National Gallery of Art, Washington, D.C., Chester Dale Collection.

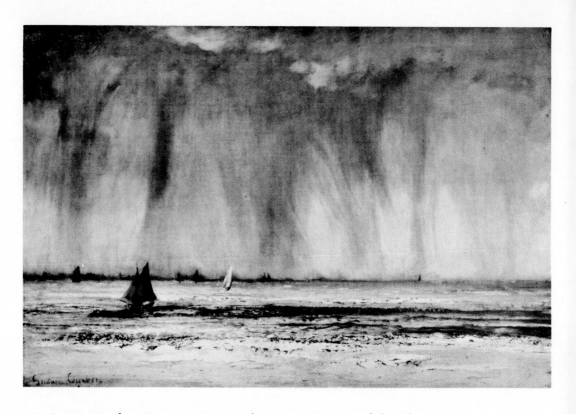

26. Gustave Courbet, *Seascape,* 1866, 16 1/2″ x 25″. Courtesy of the John G. Johnson Collection, Philadelphia, Pa.

28. *(Opposite)* John Kensett, *Cliffs at Newport,* ca. 1865, 12″ x 20″. The Museum of Fine Arts, Boston, Mass., M. and M. Karolik Collection.

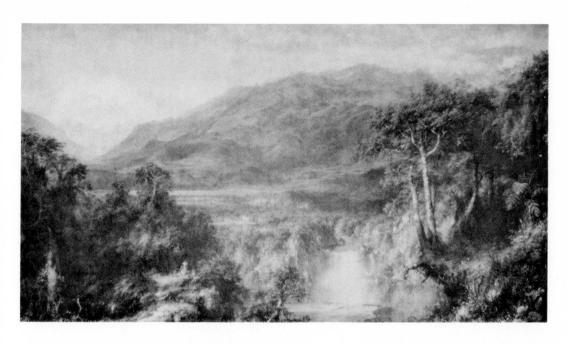

27. Frederick Church, *Heart of the Andes*, 1859, 66 1/8" x 119 1/4". The Metropolitan Museum of Art, New York, N.Y., bequest of Mrs. David Dows, 1909.

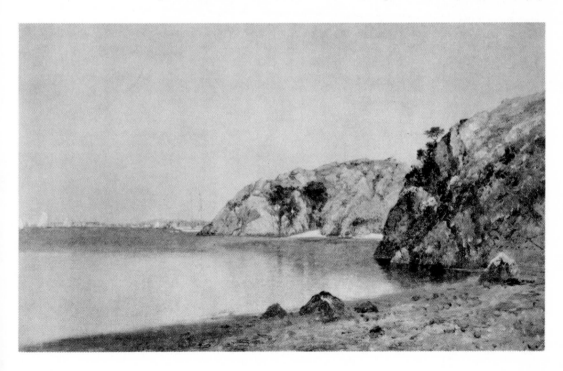

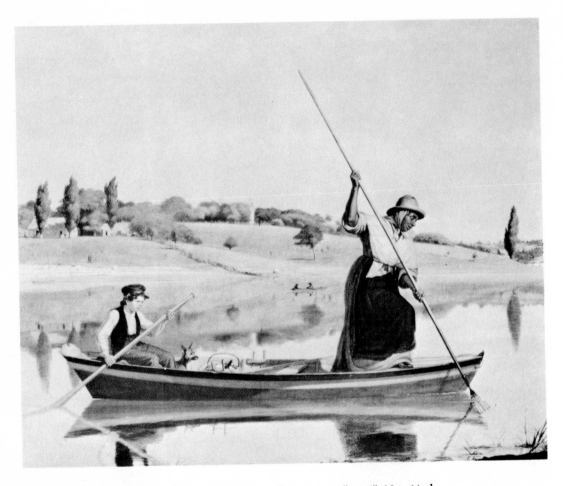

29. William S. Mount, *Eel Spearing on the Setaucket*, 1845, 29" x 36". New York
 State Historical Association, Cooperstown, N.Y.

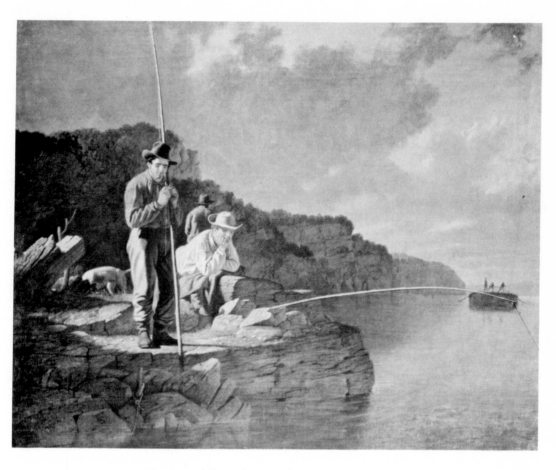

30. George Caleb Bingham, *Fishing on the Mississippi*, 1851, 29" x 36". William Rockhill Nelson Gallery of Art, Atkins Museum of Fine Arts, Kansas City, Missouri, Nelson Fund.

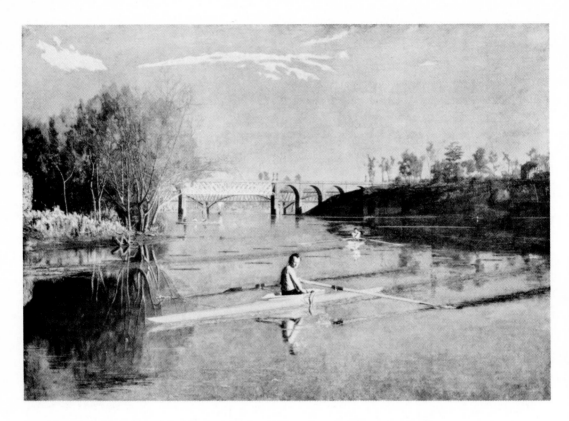

31. Thomas Eakins, *Max Schmidt in a Single Scull*, 1871, 32 1/4" x 46 1/4". The Metropolitan Museum of Art, New York, N.Y., Alfred N. Punnett Fund and gift of George D. Pratt, 1934.

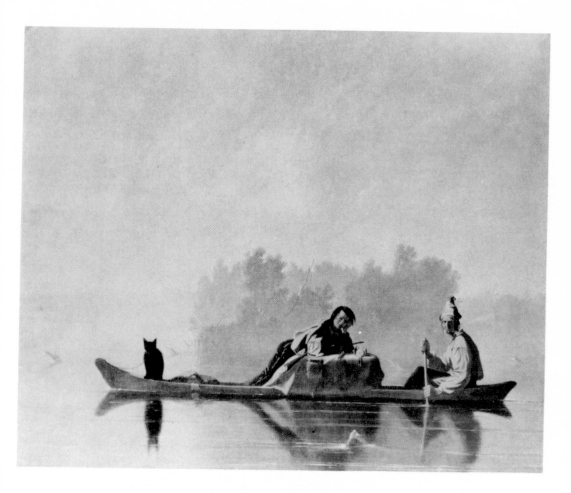

32. George Caleb Bingham, *Fur Traders Descending the Missouri, c.* 1845, 29 1/4"
x 36 1/4". The Metropolitan Museum of Art, New York, N.Y., Morris K. Jesup
Fund, 1933.

33. George Caleb Bingham, *Watching the Cargo*, 1849, 26″ x 36″. The Missouri State Historical Society, Saint Louis, Mo.

34. Thomas Eakins, *Pushing for Rail*, 1874, 13" x 30". The Metropolitan Museum of Art, New York, N.Y., Arthur H. Hearn Fund, 1916.

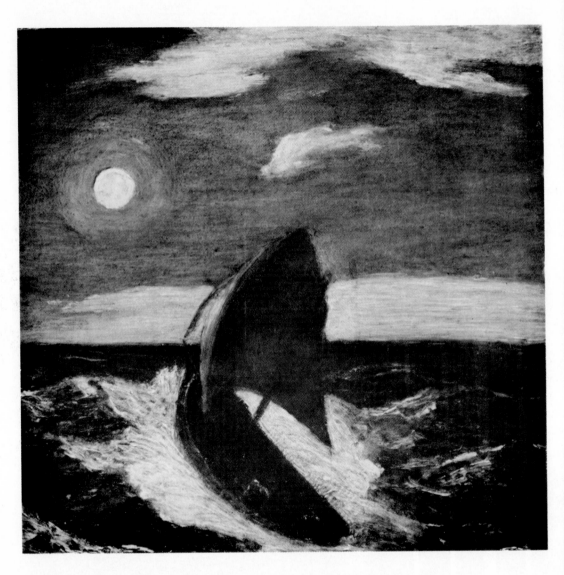

35. Albert Pinkham Ryder, *Toilers of the Sea*, before 1884, oil on wood, 11 1/2"
x 12". The Metropolitan Museum of Art, New York, N.Y., George A. Hearn
Fund, 1915.

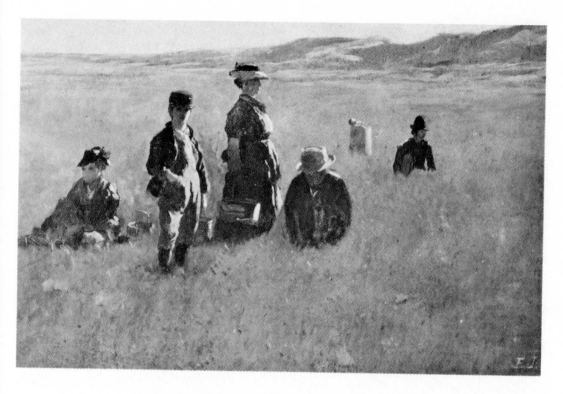

36. Eastman Johnson, *In the Fields, c.* 1870, oil on academy board, 17 3/4" x 27 1/2". The Detroit Institute of Arts, Detroit, Mich.

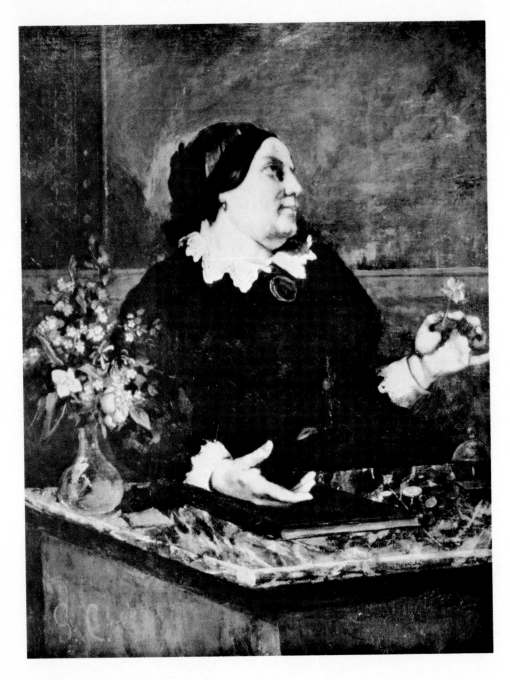

37. Gustave Courbet, *Mère Grégoire*, 1855, 50 3/4" x 38 1/4". The Art Institute of Chicago, Chicago, Ill.

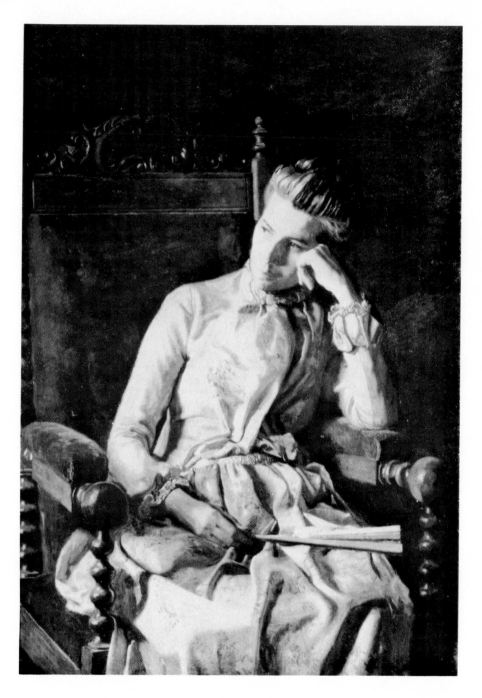

38. Thomas Eakins, *Miss Van Buren*, c. 1889-91, 45" x 32". The Phillips Gallery, Washington, D.C.

39. Thomas Eakins, *The Thinker*
(Louis N. Kenton), 1900,
82" x 42". The Metropolitan
Museum of Art, New York, N.Y.,
Kennedy Fund, 1917.

40. Gustave Courbet,
 Max Buchon, 1854,
 76 1/2" x 43 3/4".
 Musée Jenisch, Vevey,
 Switzerland.

41. Eastman Johnson, *Not At Home*, 26 1/2" x 22 1/4". The Brooklyn Museum, New York, N.Y.

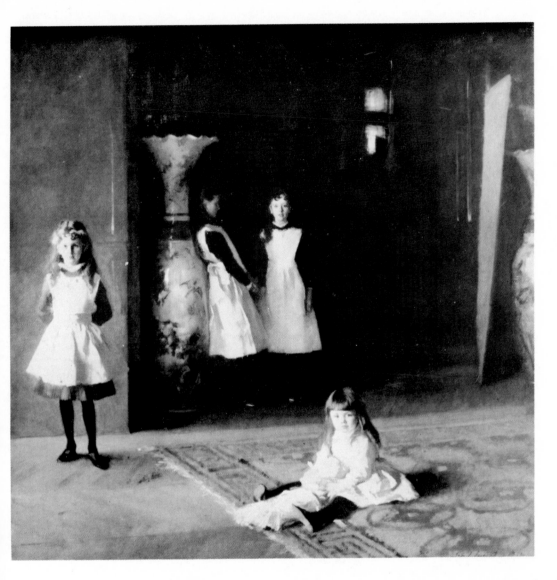

42. John Singer Sargent, *The Daughters of Edward Darley Boit*, 1882, 87" x 87". The Museum of Fine Arts, Boston, Mass.

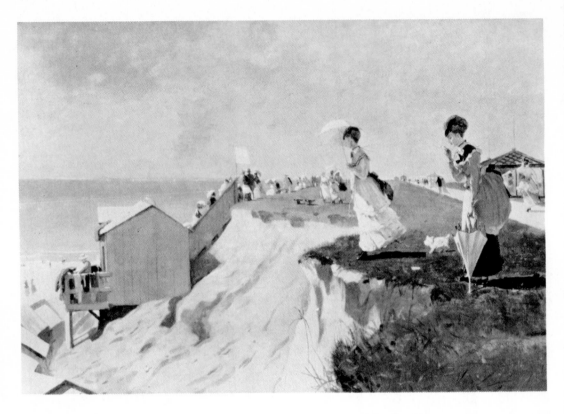

43. Winslow Homer, *Long Branch, New Jersey,* 1869, 16" x 21 3/4". The Museum of Fine Arts, Boston, Mass.

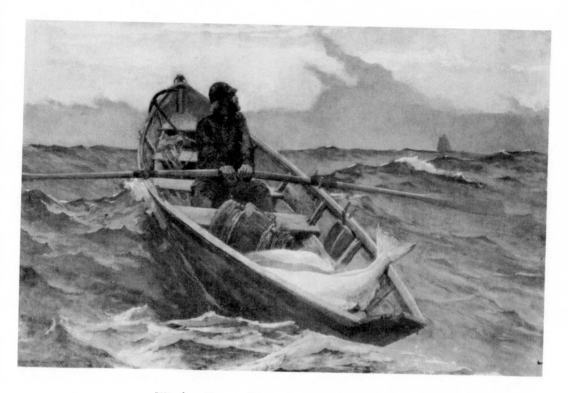

44. Winslow Homer, *Fog Warning*, 1885, 30" x 48". The Museum of Fine Arts, Boston, Mass.

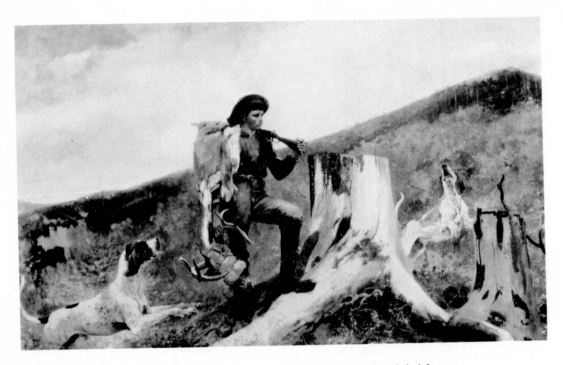

45. Winslow Homer, *Huntsman and Dogs*, 1891, 28 1/4" x 48". The Philadelphia Museum of Art, Philadelphia, Pa., William L. Elkins Collection.

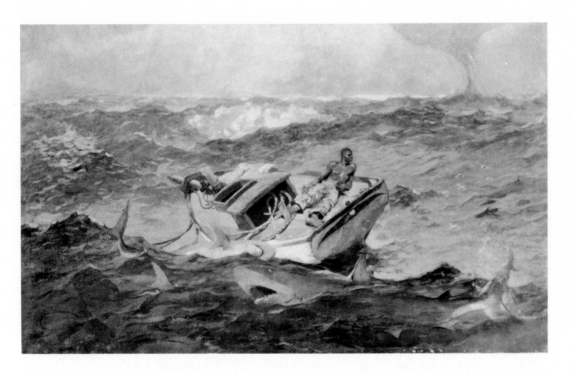

46. Winslow Homer, *In the Gulf Stream*, 1899, 30 1/2″ x 50 1/4″. The Metropolitan Museum of Art, New York, N.Y., Wolfe Fund, 1906.

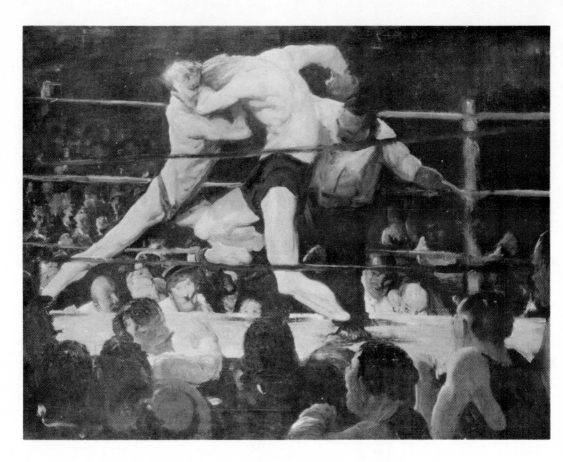

47. George Bellows, *Stag at Sharkey's*, 1907, 36 1/4" x 48 1/4". The Cleveland
Museum of Art, Cleveland, Ohio, Hinman B. Hurlbut Collection.

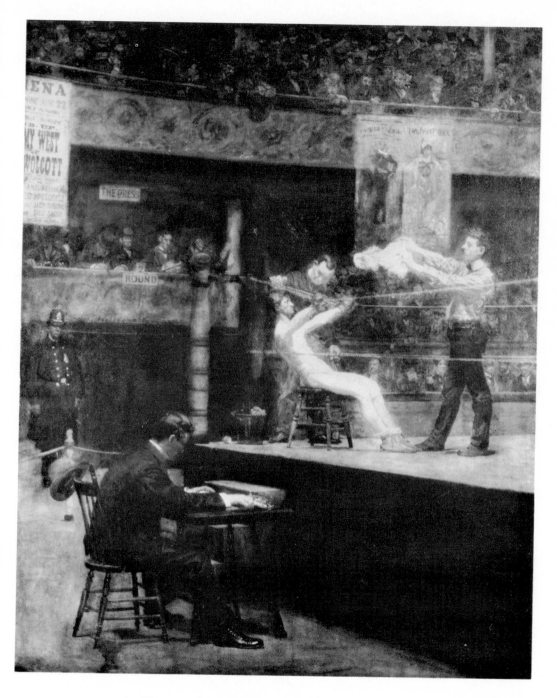

48. Thomas Eakins, *Between Rounds*, 1899, 50 1/4" x 40". The Philadelphia Museum of Art, Philadelphia, Pa.

49. Thomas Hart Benton, *July Hay*, 1943, 38" x 26 3/4", oil and egg tempera on canvas. The Metropolitan Museum of Art, New York, N.Y., George A. Hearn Fund, 1943.

50. Marsden Hartley, *Portrait of a German Officer*, 1914, 68 1/4" x 41 3/8". The Metropolitan Museum of Art, New York, N.Y., Alfred Stieglitz Collection.

51. Charles Sheeler, *Barn Abstraction*, 1917, 14 1/4" x 19 1/2", black conte crayon. Philadelphia Museum of Art, Philadelphia, Pa., Arensberg Collection.

THE RESIDENCE OF DAVID TWINING 1787.

52. Edward Hicks, *The Residence of David Twining, 1787, c. 1845-48,* 27″ x 32″.
The Abby Aldrich Rockefeller Folk Art Collection, Williamsburg, Va.

53. Georges Braque, *Houses at L'Estaque*, 1908, 28 3/4" x 25 5/8".
Collection of Herman Rupf, Bern, Switzerland.

54. Charles Demuth, *Trees and Barns, Bermuda*, 1917, 9 1/2″ x 13 1/2″, water-color. Williams College Museum of Art, Williamstown, Mass.

55. Charles Demuth, *My Egypt*, 1927, 35 3/4" x 30". The Whitney Museum of American Art, New York, N.Y.

56. Charles Sheeler, *American Landscape*, 1930, 24" x 31". The Museum of Mod-
ern Art, New York, N.Y., gift of Mrs. John D. Rockefeller, Jr.

57. Edward Hopper, *Early Sunday Morning*, 1930, 35″ x 60″. The Whitney Museum of American Art, New York, N. Y.

58. Edward Hopper, *House by the Railroad*, 1925, 24" x 29". The Museum of Modern Art, New York, N.Y.

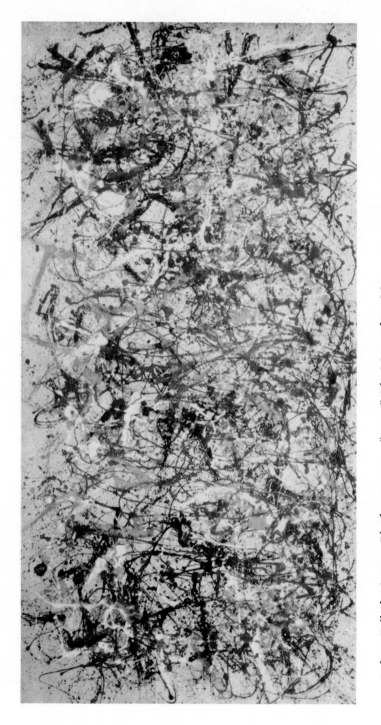

59. Jackson Pollock, *Autumn Rhythm*, 1950, 103″ x 207″. The Metropolitan Museum of Art, New York, N.Y., George A. Hearn Fund, 1957.

60. Thomas Eakins, *The Oarsmen*, 1872, 24" x 36". The Philadelphia Museum of Art, Philadelphia, Pa.

61. Willem De Kooning, *Asheville*, 1949, 25 5/8" x 31 7/8". The Phillips Gallery,
Washington, D.C.

62. Bradley Walker Tomlin, *Number 20*, 1949, 7′2″ x 6′8 1/4″. The Museum of Modern Art, New York, N.Y., gift of Philip C. Johnson.

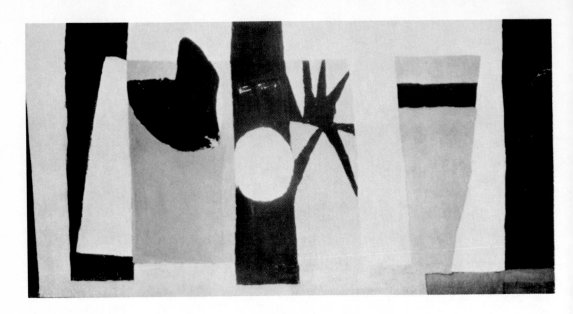

63. Robert Motherwell, *The Voyage*, 1949, 48″ x 94″, oil and tempera on paper mounted on composition board. The Museum of Modern Art, New York, N.Y., gift of Mrs. John D. Rockefeller, Third.

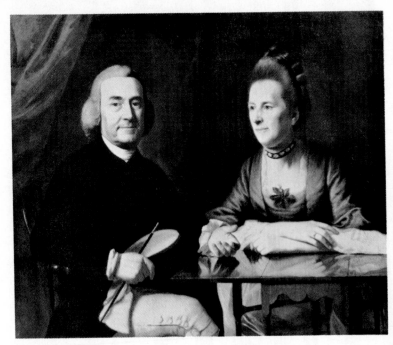

64. John Singleton Copley, *Mr. and Mrs. Isaac Winslow*, c. 1774, 54″ x 60″. The Museum of Fine Arts, Boston, Mass.

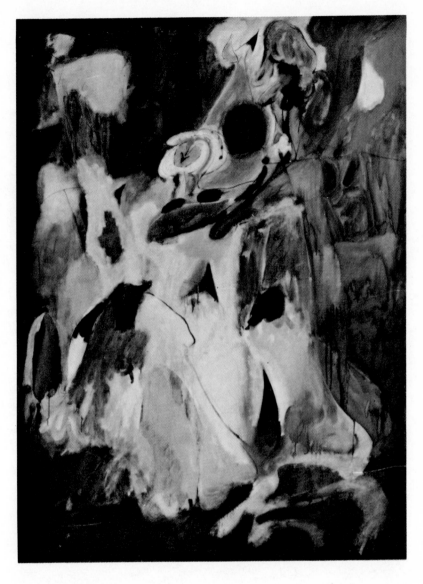

65. Arshile Gorky, *The Waterfall, c.* 1943, 60 1/2″ x 44 1/2″. Estate of the Artist. Photo courtesy of Sidney Janis Gallery, New York, N.Y.

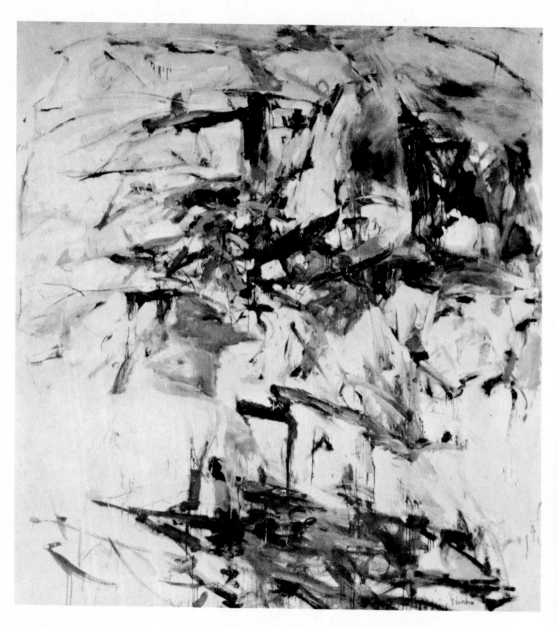

66. Joan Mitchell, *George Went Swimming at Barnes Hole, but It Got Too Cold*, 1957, 85 1/4" x 78 1/4". Albright-Knox Art Gallery, Buffalo, New York.

67. Robert Motherwell, *The Poet*, 1947, 54″ x 36″, collage. Collection, Mark Rothko. Photo courtesy of Kootz Gallery, New York, N.Y.

68. Mark Rothko, *No. 12, 1960*, (Black, Dark Siena, on Purple), 120" x 105". Collection of Dr. Panza di Biumo, Milan, Italy. Photo courtesy of Sidney Janis Gallery, New York, N.Y.

5. The New Image

Voyaging into the night, one knows not where,
on an unknown vessel, an absolute struggle
with the elements of the real.

> *Robert Motherwell*
>
> *The New American Painting*

Abstract expressionism appeared suddenly and unheralded in America just after the Second World War and, from the beginning, aroused a reaction in our press which has varied from outright derision to wild—if sometimes obscure—enthusiasm. A critic of the left has called it *"Schmeerkunst,"* and critics of the right have denounced it as subversive. Critics of some standing who had long accepted the neat rectangles of more orderly, geometric abstraction, find in its apparent reckless spontaneity and, to them, incomprehensible messiness only a deliberate denial of all values, or else they use the work of recent and less competent converts to the new painting as a device for attacking its masters. Despite the antagonism it has inspired, this painting has at last brought American art world-wide recognition, a fact which is, or should be, a source of some pride.

Exhibited in the capitals of the world, our recent painting has proved to be a significant cultural emissary, not only to the imitators it has inspired, but also to laymen, like the Dutch official at the Brussels Fair of 1958 who said, "I don't know what it is that you have, but I am surprised that you have it." American critics have been anxious to place this painting squarely in the center of an international stage. Europeans, on the other hand, have seen in it—as before them Bode, Giedion, and Zevi had seen in our architecture—the presence of a uniquely American spirit.

The origin of our new painting was not entirely an American phenomenon. Little in European painting of the previous half-century—from the late Monet to cubism and Picasso—was extraneous to its formation. But, significantly, the role of cubism and its near derivatives was a secondary one. Characteristically, the Americans did not follow a way marked by established masters, but chose instead to follow a less discernible path marked by lesser known painters. Thus, Pollock, in the early years of his abstract painting, may have found in Masson's automatic pictures of the twenties, some of the elegance and freedom he later developed in his own "controlled accidents." Gorky found himself, in part, through the fluid shapes of Miro, after his long struggle with Picasso. Each opened up dead ends left by Monet late in his career and by Kandinsky early in his. But both of these European artists were more concerned with the external world than were the two Americans. A late Monet must always be read in relation to its motifs, and Kandinsky, who some say had already done what the Americans were do-

ing, was an idealist who hoped to find a systematic language of line, shape, and color which would awaken, in the inner eye, ideas already entertained, or convey the experience of seasons or places already seen.

For the Americans, reality was to be caught only on the canvas and in the process of painting it. There was no program in what they did or in what they studied. They found much in the Dada episode and something in surrealism. What they found was characterized by the incompleteness of its statement and, perhaps, less by real paintings than by methods and assumptions about painting which emphasized the potency of uncertainty and chance in human affairs. They looked only along the edges of the European tradition, avoiding, as earlier American painters had already done, not only the magisterial works which tradition had produced, but also the certainties which it alone could provide.

One cannot say that what they created was an American style, since the term suggests an established way of painting. American artists have never known continuity of style; they have known teachers only to transform what they have been taught. American artists who have aspired to the "great tradition" have approached it only at the expense of their uniqueness. Copley looked for it in Boston but, had he attained it, he would have ceased to be an American painter. When he finally found it in London, he was lost. Being realists, most American artists have gone to the hard reality of things as Copley first did, or as Eakins did. The unity of our art lies deeper than style. It is not to be found in what American artists say, or even in what they intentionally paint, but rather in what springs from the edge of their consciousness—no more planned than were the revelations of our nineteenth-century novelists. Its unity is contained beneath the changeable look of things. Into our new painting, its way prepared by a deliberate suppression of precise, conscious control, have come the familiar signs of American experience, to be read, as always, in the nature of the space and of the things in it, and in the unique effects of a continuing American realism.

At the heart of every painting is the assumption the artist has made about its space: whether it is to be hermetic or accessible to the viewer, flat or deep, framed or unframed. In American painting, space has tended to be a shapeless void, not an atmosphere or a palpable ambience, but an emptiness. Instead of sheltering the landscape with a humanizing cloud architecture, a

cloudless sky descends to lengthen the reaches of river, field, or pavement, and to stretch the distance between things. Figures, as we have seen, do not command this space, but live tentatively within it and are given, for the purposes of picture making, only the barest means to contend with its emptiness.

In the total configuration of paintings by Pollock, Kline, and De Kooning, not in their size alone, the nature and the effect of American space is felt. The swirling, spattered drips in Pollock's *Autumn Rhythm* (plate 59) do not order or shape the pre-existing emptiness of his canvas. Rather, extending through it in patterns of minimal mass, like the thin webs of Eakins or Demuth, they confirm that emptiness, and preserve in their spontaneous trajectories, that reality. The viewer is thrust abruptly into the space of the picture, much as he was into Cole's Catskills (plate 22), and compelled to examine at close range the unending variety of its texture. For, by knowing the uniqueness of each square inch he dispels the effect, first given, of a repeated, blanketing pattern. As he does this, the viewer becomes engulfed in a seemingly total environment, as earlier the admirers of *Heart of the Andes* (plate 27), lost in wonder at the endless detail of its foliage, must have lost their awareness of the picture's edges. In Kline's *Crosstown* (plate 2), intersecting rivers of black paint seem to come from outside the picture frame, rush across the surface, and continue beyond it, giving the impression that the canvas had only intercepted them by chance. Their rush across and out of the picture, echoes, in abstract terms, the flight and vacancy of Johnson's *Not at Home* (plate 41). Both Kline and Pollock invade a space which remains inviolate. De Kooning's paintings, on the other hand, are full of shapes giving no sense of a pre-existing void. His *Asheville* (plate 61) suggests a landscape, but its jagged, bumping shapes and strident color make it a hostile one. Crowding each other and pressing toward the edges of the picture, they nevertheless suggest, like the patterns of Pollock and Kline, fragments torn from an unformed and continuing environment.

In the work of all three painters is preserved an abiding American conception of the landscape as "an area of total possibility," a phrase borrowed from R. W. B. Lewis who, unaware that he was echoing the language of contemporary American art criticism, used it to describe Cooper's attitude toward the landscape settings of his novels.[14] Our nineteenth-century land-

scapists painted, as Cole put it, places where one day the plow would glisten. Frequently, the unspectacular tracts they painted, where in the future something might happen, be built, or made to grow, are redeemed only by this promise. The ground of white or raw canvas left by Kline and Pollock remains in evidence of the unmarked void they first approached, a void unconditioned by preconceived images and scarcely shadowed by an intention. In none of them is the primal area of promise shaped or hollowed and, in the unfinished appearance of their work, the final statement is postponed.

The paralyzing force of the American environment challenges these painters as, before them, it had challenged the Eight and the regionalists, and they meet it with a similar show of violence, in Pollock's case, perhaps directly inherited from Benton's twisted, restless contours. Just as the American realism of the Eight and their followers was a criticism of our nineteenth-century realism, so our new abstraction is a reaction to the more timid American abstraction of the twenties and thirties. Like our realism, it too was, for all its debt to Europe, a flight away from Europe. The abstract expressionists, like many of their realist counterparts, project a raw energy in their painting; but in their work, paths of quick flight and stabs of paint are only graphs of violence, and not self-limiting. With their new freedom and boldness, they strike out into the American space of their pictures, raging against the emptiness with the same sweeping strokes which evoke it. If these American pictures appear raw and violent in contrast to contemporary European ones, if Kline's picture is all that Soulages' is not, it is because the Americans have consciously preserved some of the unconscious forcefulness of the primitive.[15]

Pollock, De Kooning and Kline offer the viewer no asylum. Their passages of paint, though at times overwhelmingly close, are occupied with grand distances and unconcerned power. Their paint is not put down for its own sake, and when, as in De Kooning's *Asheville* (plate 61), the paint does become rich and opulent, that richness is held in tension with black, biting lines, and with passages of color in the hues of cheap cosmetics or dime-store plastics. There is none of the European materialism we observed in Soulages' painting. There has never been any in American painting; it has always been consumed in the imagery without love or real attachment.[16]

The American reluctance to order the space of pictures with enclosing ele-

ments, to stabilize shapes within it, or to temper their apparent randomness, is a measure of American realism, and continues in our new painting to produce typically American results. Soulages' immaculate strokes, in their contribution to a satisfying unity, are self-explanatory; Kline's evoke the myriad random events we witness every day. Eakins, who scorned those means his European contemporaries found to soften the cranky effects of chance in their pictures, did much the same. In paintings like *Oarsmen* (plate 60), he seized an unpromising moment: when the complex outline of two rowers and their fragile shell was visually entangled with the simple, overwhelming mass of a stone pier supporting an unseen bridge. In this strange meeting, the human figures are overwhelmed—for Eakins did nothing to rescue them—and the result is characterized by the same powerful, inhuman intersections of Kline's apparently fortuitous strokes, for both artists reject the easy fictions of their pictorial idioms.

Others among our abstract painters have avoided the apparently headlong methods of Kline, Pollock, and De Kooning. The late Bradley Walker Tomlin, one of the older painters of the group, preserved traces of a geometry in his rectangular strips of white. His colors, as Laurence Gowing has noted, recall the crisp play of American light on white clapboard, the white strips of Copley, and, instead of asserting a fixed organization in space, "spell out the natural consistency of disorder" (plate 62). Robert Motherwell's similarly loosened rectangles in *The Voyage* (plate 63), echo, in their uncertain placement, the awkwardness of Copley's *Mr. and Mrs. Isaac Winslow* (plate 64). Across both pictures the eye is impelled to a discontinuous movement. In Motherwell's abstraction, this movement is from one slightly tipped rectangle to the next; in Copley's portrait, it is from one figure and from one spotted area of light to the next. Through the crossed forearms of Mrs. Winslow, the open hand of her husband, his hat and closed hand, is a discontinuous, almost random horizontal, corresponding to the one formed in Motherwell's picture by the hyphen of black on the right, the open, jagged black at the center, and the closed black shape on the left. The sense of impermanence in the abstract painting is further conveyed by the shifting relationship of figure to ground, for the white vertical on the left is read as figure sliding over the black, but, on the right, the white is seen to disappear behind a black and become, at the same time, fused with the white ground. In the

portrait, such shifting is impossible, yet Copley's figures exist in a plane close to the surface, and in that plane they derive a similar impermanence from the unresolved composition. Furthermore, as Copley pushed his realism, he painted into his picture the self-consciousness of his sitters in the unfamiliar act of posing side by side with elbows touching awkwardly. He thus furthered the sense of transience derived from his composition in the abstract. The figures seem as ready to move as Motherwell's shapes; both exist in a context of time and imminent change. Despite the enormous differences between them, the same American leavening is at work.

The old realism in a new guise is as implicit in the methods of the new painters as it is evident in their finished works. Their denial of a complete and perfect order involves the assumption that the moment of painting, like other moments of life, is subject to accident, error, and indecision. Pollock could not easily correct or change his famous "controlled accidents" once they had occurred; as in most other moments of life, he could only go on building from earlier, perhaps regretted, decisions. Similarly, De Kooning's and Kline's pictures are made to retain, in their dripping lines, smears, and ill-concealed changes, the arduous, uncertain labor of their creation. The admission of chance and accident into the process of painting is their realism, the abstract counterpart of what our earlier realists chose to *see* in the concrete world of objects. It is from this process that the continuing American qualities of this new art stem: the unmeasured spaces, apparently haphazard composition, the hostile, indifferent surfaces, and the overriding impression they give of being fragments of a vast, continuing process beyond the control of their makers.

This courting of chance was not uniquely American for it was also present in the inspired nonsense of the Dada painters. A similar attitude is widespread in modern literature, where the sudden, unsuspected conjunction of two words may convey a truth which can grow only out of that specific encounter. Indeed, the painters' methods recall Auden's remark: "I have to see what I write in order to know what I mean."[17] It is fair to ask: who is this "I," and what can that "what" mean? But in this process the "I" is not an idle manipulator of shapes, waiting for something to happen. Although some of the painters in question have spoken of abandoning the swamps of history and memory, the "I" still represents all that the painter knows, all

that he has learned from the study of his art, from other pictures, and from nature. It is that knowledge which qualifies the infinite number of decisions he must make in the process of painting, tells him when to stop, and enables him to recognize what he has found. That "what" of Auden's statement is that moment in the picture's birth when disorder, which the painter accepts as a condition of life, is most delicately balanced by all his painter's eye and mind tell him is the first minimal presence of order. Thus, by a process of divestment, the new painters have paralleled the effects achieved by older American artists out of their innocence. These men are all puritans at heart, not because they have deserted the image, but because they have not called upon the full resources of painting, and, in their honesty, have never masked their uncertainty. They admit "art" only in a tentative and precarious triumph over chaos, a triumph no more complete than that won by Copley with his loose-knit assemblages of crisp cloth and bright buttons.

The new artists have rightly denied that their art was abstract at all. Their paintings are something found in the process of painting. Each picture has a specific impact which denies precise reference to objects outside it, especially the kind of reference which an abstract geometric style, like Mondrian's, makes in its homage to the value of precision, to machine-made objects, or to an ideal of perfect order. Each picture is almost perfectly irreproducible. If half-formed images do spring from them, it is not because they were consciously put there, but because of the viewer's human need to link, somehow, the painted surface to the world of common experience and humanly constructed order. The images which sometimes are evoked—in Pollock's pictures, the flight of a swallow, or brown leaves and black branches stirred by an autumn wind; or in Kline's, brutal, urban fragments of bridges, girders or black asphalt—are fugitive and never certainly there. All of them call not upon fixed things but upon restlessness and change, things half-seen passing or passed through. Ultimately, this sense of motion and change must be referred back to the canvas itself, for it is one with the apparently swift, changeful process of painting which has left its traces upon its surface.

Some American painters have avoided the violence of Pollock, De Kooning, and Kline, to work in a gentle, more introspective manner. Instead of storming unassailable spaces with paint flung into them, they have individ-

ually developed more subtle means of infiltrating space with tentative lines and less clearly formed shapes, or they have fused figure and ground, making one appear to grow out of the other to avoid the bleakness of direct confrontation. In this they achieve a new relation between art and nature, becoming, as they paint, part of nature's processes and making pictures which seem, like nature itself, to grow and change before the viewer.

Thus, in a painting like Gorky's *The Waterfall* (plate 65), the spots of green and yellow suggest broken sunlight and cool shade, and its unformed shapes spill down through the picture like falling water; they are not there to imitate visible nature by taking up measurable positions in space. The picture's title was called up by the colors and by the fluid, lapping, interpenetrating, and seemingly changing configuration of shapes already there. Similarly, in Joan Mitchell's *George Went Swimming at Barnes Hole, but It Got Too Cold* (plate 66), a memory involving cold water on a given day is transformed into a general statement in which jagged, stabbing lines of black against cold blue and white may suggest branches against a cold sky or become black water breaking through ice in early spring. But the imagery of both pictures is only suggested. It is not of something drawn from outside into the picture to be embellished, geometricized or otherwise tortured. Rather, it grows as one with the painting, and thus the traditional role of the artist before nature has been reversed; his intuitive manipulation of paint becomes endowed with meaning, and the peculiarly American separateness of person and place, painter and object, is thereby resolved.

Out of this new fusion of form and content to which process has been wedded as an active principle, come pictures like Phillip Guston's, recalling the distant vistas of landscape. But their hills and cities are only hinted at, they take shape only in short, irresolute squiggles of paint tentatively gathered out of the undefined ambience of which they are but half free. Motherwell's *The Poet* (plate 67) does not recall visible nature but, as its title suggests, the unseen processes of thought. Instead of using visual puns or ideograms as Klee might have done, Motherwell finds his meaning in the indecision and hesitancy of his painting. Two oval shapes against an unsettled ground of irregular rectangles are seen in delicate tension, one above the other. From the upper one reaches an antenna-like black line, put down almost diffidently. From it, another one teeters to the right, changes color at

the top, and tends to lose itself in the background. As one looks at it, the whole composition seems only on the point of coherence. The ovals seem about to spring free of each other, and the antennae above seem to probe for the first signal of an idea that will perhaps give final shape to the whole.

Mark Rothko's variations of vague rectangles against close or contrasting backgrounds summarize the American visual experience, but their geometry is only a reference to the possibility of an order which is not claimed. It is denied by blurred, imprecise contours, and by the limitless depth of his softly brushed, surfaceless color which is floated out to the very edge of the painting or seems to expand toward it. In a final denial of this vestigial geometry, figure and ground can—and often do—change in relation to each other. The ground can come forward, making a rectangle, which had seemed to float over it, appear to be a distant view seen through it. The observer cannot respond to solid shapes in a defined space. He may contemplate the emptiness of a picture like *No. 12, 1960* (plate 68) and feel disembodied by its weightlessness, or he may himself become immobilized, like so many figures in our landscapes, in contemplating its measureless emptiness. Perhaps he may watch, entranced by the possibility that, in the permeable color, something might take shape, or that something may be hidden behind it. Without this possibility, the picture seems scarcely enough. So delicately has the artist intervened that the painting seems to have taken shape by itself, innocent of his direction. Like all American pictures, it cannot be possessed, for the artist has not chosen to possess his medium. Once again, in order to paint the reality of American experience, which is spiritual and not material, our artists are living on the edges of art.

The tendency to slip away from realism into a state of melancholy reverie has long been present in our painting, and the vein of hesitant introspection in some of the new American work is in the tradition of Ryder, late Inness, Blakelock, Dewing, and even Whistler. In the works of these earlier artists, typical American patterns of unresolved shapes, floating, transient images, and isolated figures are to be found. But, in their partial withdrawal from the image, these artists more often threw over their pictures a cloak of palpable atmosphere—sometimes a thin impressionism—which dissolved their contours and obscured the texture of what they represented. Their paintings became mood pictures, American in temperament, but general in form. Their

contemporaries in the late decades of the nineteenth century—Homer, Eakins, and Johnson—never lost the special look of what they painted, and the spell of inaction and resignation which they too felt is expressed in tension with the commanding, local immediacy of their realism. Our new abstraction preserves this unique tension of American painting: for Pollock, Kline, or De Kooning, it exists between the raw presence of paint and endless space, for their more subdued contemporaries it exists between the acutely American experience of continuity in space and time, and the stable world of solids and voids with which painting has traditionally been concerned. For all of them it lies between the act and its completion: chaos and control.

It would therefore appear that a unique combination of circumstances has given American art not the homogeneity of a style but basic similarities beneath a chaotic variety of individual styles. Of special service to the American artist has been an abiding, if unstated, distrust, not only of the image itself but also of the immediate and material splendors of the whole Western tradition of painting. American realism, born paradoxically out of that distrust, has been obsessed with objects at the expense of those unifying elements which, in traditional painting—or at least in the tradition of baroque painting—subordinate the separateness of things to a satisfying wholeness. As a true realist, the American painter has never controlled what he has chosen to paint; he has only looked upon it and allowed what he has seen to remain inviolate, as though he had never been there at all. He has always been, since his beginnings, not a baroque but a modern man.

He saw first an untouched, natural disorder containing the innocence of an Eden and the promise of the future. Still with an uncertain grip on the present, he looked upon the unplanned and swiftly changing face of America as something beyond his power to control. Consequently, American artists have seldom felt obliged to learn the mastery of their art. Those that did have had to forget it, for the essential experience of America can never be the subject of traditional pictorial methods. This essential experience is of the individual standing alone in a sea of space and of change. If this is a modern phenomenon, expressed in European painting as well as in American, it can only be said that American artists have always been modern. In recent years, their rejection of the brilliant but enforced order which European artists have created against the uncertainties of the modern world, in

favor of a dimensionless style which lives intimately with doubt, has illuminated a long history of similar, if less conscious, rejections.

Seen first in the wilderness where it was born, and later in the cities into which it was extended, invading domestic interiors where it did not in fact exist, the physical extent of America has been both a prime cause of this American isolation and, in our painting, its outward sign. Gertrude Stein has written:

> After all anybody is as their land and air is . . . Anybody is as the sky is low or high, the air heavy or clear and anybody is as there is wind or no wind there. It is that which makes them and the arts they make and the work they do and the way they eat and the way they drink and the way they learn and everything.[18]

We do not yet possess this land with the deep knowledge that comes of long living on it, and it may be that in our ceaseless moving over it we never shall possess it. A truly modern people may never be permitted to do so.

Notes to the Text

1. I am indebted to Mr. Alan Ludwig for knowledge of this stone. It is one of many he has photographed and catalogued in preparing a publication on this surprisingly neglected art form rich in symbolism and artistic quality.

2. From "A True Sight of Sin," quoted in Perry Miller's *The American Puritans*, New York, Doubleday Anchor Books, 1956.

3. For an extended discussion of this architecture, see V. J. Scully, Jr., "The Precisionist Strain in American Architecture," *Art in America*, No. 3, 1960, pp. 46-53.

4. O SOLITUDE! if I must with thee dwell,
 Let it not be among the jumbled heap
 Of murky buildings; climb with me the steep,—
 Nature's observatory—whence the dell,
 Its flowery slopes, its river's crystal swell,
 May seem a span; let me thy vigils keep
 'Mongst boughs pavillioned, where the deer's swift leap
 Startles the wild bee from the fox-glove bell.
 But though I'll gladly trace these scenes with thee,
 Yet the sweet converse of an innocent mind,
 Whose words are images of thoughts refin'd
 Is my soul's pleasure; and it sure must be
 Amongst the highest bliss of human-kind,
 When to thy haunts two kindred spirits flee.

5. M. D. Conway, "The Great Show in Paris," *Harper's New Monthly Magazine*, XXV, 1867, p. 248.

6. A theme to be explored in Mr. David Huntington's forthcoming study of Church.

7. "The Snow Man," in *Collected Poems of Wallace Stevens*, New York, Alfred A. Knopf, 1957.

8. *Cranbrook—Life Exhibition of Contemporary American Painting*, May 17-June 2, 1940, Cranbrook Academy of Art, Bloomfield Hills, Michigan.

9. "There is the objection that the school [Eakins' Pennsylvania Academy of Fine Arts] does not sufficiently teach the students picture-making, and it may be met by saying that it is hardly within the province of the school to do so. It is better learned outside, in private studios, in the fields, from nature, by reading, from a careful study of other pictures, of engravings, of art exhibitions, and in the library, the print room, and the exhibitions which are held in the galleries." Quoted in *Thomas Eakins Who Painted* by Margaret McHenry, 1946, from Fairman Rogers, "The Art Schools of Philadelphia," *Penn Monthly*, September, 1879.

10. Quoted in Lloyd Goodrich, *Albert P. Ryder*, New York, George Braziller, 1959, p. 13.

11. See Fairfield Porter, *Thomas Eakins*, New York, George Braziller, 1959.

12. V. J. Scully relates the spatial flow of the Sargent portrait to the nascent development of similar attitudes toward space in the American domestic architecture of the 1880's, which he has called the "shingle style." The fruit of this development he has shown in the architecture of Frank Lloyd Wright, whose buildings epitomize dramatically that sense of spatial continuity which invests our painting. For a discussion of Sargent's picture in this connection, see "American Villas," *The Architectural Review*, March, 1954, pp. 169-179.

13. *The Works of Theodore Roosevelt.* Memorial Edition, 24 vols., New York, Charles Scribner's Sons, 1923-26, Vol. XIV, pp. 461-62.
14. R. B. Lewis, *The American Adam,* University of Chicago Press, 1955.
15. See Harold Rosenberg, *The Tradition of the New,* New York, Horizon Press, 1959.
16. On American versus European materialism, see Mary McCarthy's "America the Beautiful," *Perspectives, U.S.A.,* No. 2, Winter, 1953, pp. 11-21.
17. Quoted in Charles Fiedelson, *Symbolism and American Literature,* University of Chicago Press, 1953, a brilliant analysis of the creative processes of American fiction which parallel, in many ways, those of our painters.
18. From "An American and France" by Gertrude Stein in *What Are Masterpieces,* Los Angeles, Conference Press, 1940, p. 62.

Bibliographical Note

Excellent bibliographies of American painting are available in E. P. Richardson, *Painting in America,* New York, Thomas Crowell Company, 1956, and in O. W. Larkin, *Art and Life in America,* New York, Rinehart & Company, 1949.

Useful studies of specific periods in American painting are: L. Dresser, *Seventeenth-Century Painting in New England,* Worcester, Mass., Worcester Art Museum, 1935; F. A. Sweet, *The Hudson River School and the Early American Landscape Tradition,* Chicago, Art Institute of Chicago, 1945; J. I. Baur, *The Eight,* New York, The Brooklyn Museum, 1934; M. Brown, *American Painting from the Armory Show to the Depression,* Princeton, N. J., Princeton University Press, 1955; J. I. Baur, *Revolution and Tradition in Modern American Painting,* Cambridge, Mass., Harvard University Press, 1951; J. I. Baur and L. Goodrich, *American Art of This Century,* New York, for the Whitney Museum by Frederick A. Praeger, Inc., 1961; and S. Hunter, *Modern American Painting and Sculpture,* New York, Dell Books, 1959.

This essay is also indebted to the writings of V. J. Scully, Jr., on American architecture, especially his *The Shingle Style; Architectural Theory and Design from Richardson to the Origins of Wright,* New Haven, Yale University Press, 1955; and to the following works on American literature: D. H. Lawrence, *Studies in Classic American Literature,* New York, Doubleday, 1953; L. Mumford, *The Golden Day,* New York, Boni and Liveright, 1926; Richard Chase, *The American Novel and Its Tradition,* New York, Doubleday, 1957; M. Bewley, *The Eccentric Design,* New York, Columbia University Press, 1959; R. W. B. Lewis, *The American Adam,* Chicago, University of Chicago Press, 1955; C. Fiedelson, Jr., *Symbolism and American Literature,* Chicago, University of Chicago Press, 1953; and H. Rosenberg, *The Tradition of the New,* New York, Horizon Press, 1959.

Index

Plate numbers are in italics. All plates are on pages 49-112.

DATE DUE